IMAGES
of America

JEWISH COMMUNITY
OF DAYTON

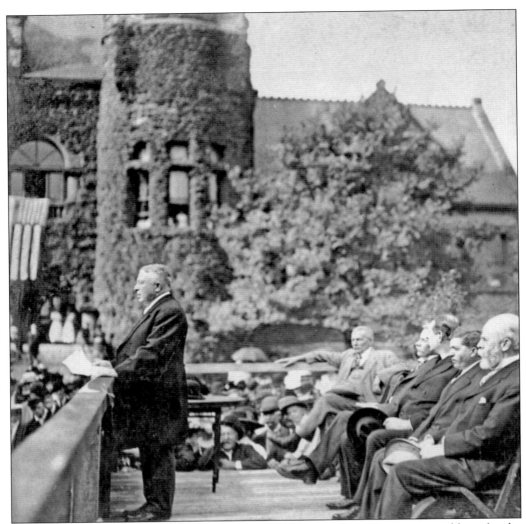

Dayton Chamber of Commerce president Leopold Rauh delivers the opening address for the dedication of the statue of Pres. William McKinley at Cooper Park in front of the Dayton Public Library and Museum on September 17, 1910. Born in Bavaria (now part of Germany) in 1850, Rauh arrived with his family in America in 1865. He joined his father, E. Rauh, in the hide and tallow business in Dayton. Rauh also purchased the Egry Register Company, which he expanded to become one of Dayton's "important industries," according to the *Dayton Daily News*. He served on Dayton's board of education and on the commission that established Dayton's city manager plan of government after the Great Flood of 1913. At his death in 1915, the *Dayton Daily News* called him one of Dayton's "most public spirited citizens." (Dayton Metro Library.)

ON THE COVER: Golda Meyerson (later Golda Meir), a member of Israel's provisional government, receives a $300,000 check in Dayton on June 8, 1948, from United Jewish Campaign chair A.B. Saeks for the weeks-old Jewish state, fighting for its life against five Arab armies. With them at the Biltmore Hotel are Sam Thal (left) and Ben Shaman. (Jewish Federation of Greater Dayton Archives, Special Collections and Archives, Wright State University.)

IMAGES
of America

JEWISH COMMUNITY
OF DAYTON

Marshall Weiss

ARCADIA
PUBLISHING

Published by Arcadia Publishing
Charleston, South Carolina

Printed in the United States of America

Library of Congress Control Number: 2018940693

For all general information, please contact Arcadia Publishing:
Telephone 843-853-2070
Fax 843-853-0044
E-mail sales@arcadiapublishing.com
For customer service and orders:
Toll-Free 1-888-313-2665

Visit us on the Internet at www.arcadiapublishing.com

"Seek the welfare of the city to which I have exiled you and pray to the Lord on its behalf; for in its prosperity you shall prosper." —Jeremiah 29:7

CONTENTS

ACKNOWLEDGMENTS

Thanks go to the following for their expertise, assistance, and wisdom:

- Cathy Gardner, chief executive officer of the Jewish Federation of Greater Dayton, for her enthusiasm and support
- Dawne Dewey, head of Special Collections and Archives, Wright State University, who facilitated the establishment of the Jewish Federation Archives there in 2011
- Nancy R. Horlacher, local history specialist, Dayton Metro Library, for her encouragement and for reviewing this manuscript
- Curt Dalton, visual resources manager, Dayton History, who reviewed this manuscript and tracked down key images
- Sandy Schoemann, Dayton Jewish Genealogical Society, for her meticulous research whenever I needed anything
- Bill Stolz, archivist/reference and outreach, Special Collections and Archives, Wright State University, who aided with every possible request
- Joe Weber, project archivist, Jacob Rader Marcus Center of the American Jewish Archives, for his speed providing me with materials
- Shelly Charles, for superb images and hours of conversation about old Dayton
- Stuart Rose, for his generous support of this venture and his love of Jewish Dayton
- Ellen Finke-McCarthy, administrative assistant, Temple Israel, whose passion for genealogy was invaluable regarding the history of Dayton's oldest Jewish congregation
- Stacia Bannerman, senior title manager, and Tim Sumerel, production editor, Arcadia Publishing, for their commitment to the highest editorial standards
- Peter Wells, Jewish Federation's retired executive vice president, for sage advice along the way
- The late Dr. Leonard Spialter, founder and longtime president of the Dayton Jewish Genealogical Society—every fact he compiled was spot-on
- The Jewish Federation Archives and Special Collections Fund in Memory of Debra L. Schwartz
- Proofreaders Karen Bressler, Rachel Haug Gilbert, and Pamela Schwartz for brilliantly cleaning things up
- My family—Donna, Levi, and Adina Weiss—for listening to all the stories

KEY TO COURTESY ABBREVIATIONS

AJA: Jacob Rader Marcus Center of the American Jewish Archives
DDN/WSU: Dayton Daily News Collection, Special Collections and Archives, Wright State University
DH: Dayton History
DJO: *Dayton Jewish Observer*
DML: Dayton Metro Library
JFGD/WSU: Jewish Federation of Greater Dayton Archives, Special Collections and Archives, Wright State University
WBC/WSU: Wright Brothers Collection, Special Collections and Archives, Wright State University

INTRODUCTION

"He Who blessed our forefathers, Abraham, Isaac, and Jacob—may He bless this entire holy congregation along with all the holy congregations . . . and those who dedicate synagogues for prayer and those who enter them to pray, and those who give lamps for illumination and wine for Kiddush and Havdalah, bread for guests and charity for the poor; and all who are involved faithfully in the needs of the community."

This prayer, from the Sabbath morning service in traditional Jewish liturgy, was at the front of my mind when I compiled *Jewish Community of Dayton*.

From 1850 onward, Dayton's Jews not only provided for the spiritual and material needs of their own, they also involved themselves faithfully in the needs of Dayton's general community. If there is a message to be found in this volume, this is it.

These pages offer a family photo album of the Jews of Dayton, from those early days through the close of the 20th century. The story beyond that is for another generation to consider.

Jewish Community of Dayton grew out of the Jewish Federation of Greater Dayton's centennial celebration in 2010. Then Jewish Federation CEO Larry Skolnick, centennial chairs Judy Abromowitz and Pamela Schwartz, and I came up with plans for a 10-panel exhibit, *Ten Decades of Tzedakah*, to illustrate the history and impact of the federation. Each panel was also printed as a page in the *Dayton Jewish Observer* over the course of the federation's centennial year and was posted at the federation's website, jewishdayton.org.

Two years before, we were horrified to realize that most of the federation's early materials were piled in heaps in the basement of Covenant House, Dayton's Jewish nursing home. An archivist by trade, Pamela volunteered to properly preserve, catalog, and store the collection, with help from graduate students in Wright State University's public history program, the graduate program she had completed years before. In 2011, Wright State Special Collections and Archives accepted the federation's collection.

With the organization and preservation of the federation's collection under way, the notion of a book about Dayton's Jewish history came into focus. I began digging into the archival collections of Dayton's oldest Jewish congregations: Temple Israel, Beth Jacob Congregation, and Beth Abraham Synagogue. However, I had to put the project on hold over the years immediately after the Great Recession of 2008 to help with additional Jewish Federation staffing responsibilities at a time of budget tightening and to concentrate on keeping the *Dayton Jewish Observer* financially viable.

Thankfully, in more recent years, the federation and *Observer*'s financial situations have stabilized, and with the blessing of current Jewish Federation CEO Cathy Gardner, I was able to return to the book project. Little did I realize that the delay itself would provide a blessing: nearly a decade later, access to genealogical tools and historical materials via the Internet was much more readily available.

The aim of this volume is not to idealize but to help new generations discover glimpses of Jewish life in Dayton that might otherwise be forgotten. America has provided unprecedented freedoms and opportunities for the Jewish people. This is the story of how they navigated these freedoms and opportunities—and the obstacles they overcame—in the Gem City of the Golden Land.

The earliest characteristic to divide Jews in America's local communities was region of European origin. German Jews, who settled in Dayton first—at least a generation before the Jews of eastern Europe—were at the top of the Jewish community, socially and philanthropically, at least until the other groups acclimated and caught up. Eastern European Jews had their distinctions too. If a Russian Jew married a Lithuanian Jew, it was practically considered an intermarriage. After World War II, when American Jews became aware of the horrors of the Holocaust, these distinctions faded.

Even amid religious distinctions, the obligation of Jews to take care of each other has bound the Jews of Dayton. Immediately after the Great Flood of 1913, Max Mann, who owned the only kosher slaughterhouse in the city, was forced to suspend operations temporarily. Harry J. Jacobs, a Reform Jew who owned a nonkosher meat storage plant in Dayton, placed his establishment at the disposal of the Federation of Jewish Charities so that "the strict 'Kosher' meats may be obtained by the Jews of the city," according to the *Dayton Journal*. At the time, the federation was led by German Jews from Dayton's Reform community. A month later, at Passover, the federation distributed 10,000 pounds of matzah to Dayton's Jews in need—those who already lived in poverty and those who had lost so much in the flood. Matzah was particularly scarce; soon after the flood, hungry citizens of Dayton seized six train cars of matzah when regular bread could not be found. The *Dayton Journal* reported that "the entire population depending upon this relief station fell back upon this unleavened bread. Catholics, Protestants and Jews alike clamored for it when other bread supplies were scarce."

Did the early Jews in Dayton encounter prejudice? Certainly. At every turn? No. In a 1981 interview with Lisa Denlinger for a Wright State University project, retired attorney Benjamin Shaman, then 89, put it best: "As I grew up, I was taunted by my Catholic schoolmates. In Russia I would have been punished for fighting back whereas in America I could fight back." Shaman would go on to serve his congregation, Temple Israel, and the Jewish Federation in virtually every key leadership position. He would also chair Dayton's school board and serve as president of Barney Convalescent Hospital, now Dayton Children's Hospital.

Some will look at this volume with frustration that a person dear to their memory was not included. Please know that this work is not intended as an exhaustive history of Dayton's Jewish community. It is not possible in this book to include the names and stories of all who worked so hard to build up our Jewish life here in Dayton, to include all those Jews who dedicated themselves to improve the quality of life of the Dayton community as a whole. In the spirit of the Day of Atonement, I ask your forgiveness and understanding.

What will future generations record of us when we are nothing more than history? That will depend on how we carry Jewish life forward for our benefit, and theirs.

Author Marshall Weiss is founding editor and publisher of the Dayton Jewish Observer *and a past president of the American Jewish Press Association.*

One

BEGINNINGS

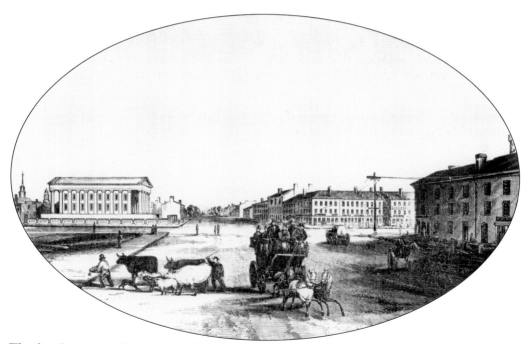

The first Jews to settle permanently in Dayton arrived in the early 1840s. They had emigrated from Germany, where they were prohibited from certain professions, from places they could live, and often from legally marrying. This 1851 illustration of a view looking north along Main Street—with the newly completed Montgomery County Court House (left) at Third and Main Streets—gives a sense of the scene that greeted them. (DML.)

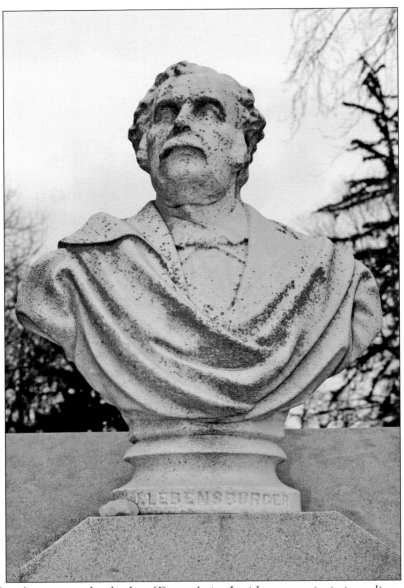

Joseph Lebensburger was a key leader of Dayton's tiny Jewish community in its earliest years. Born in Bavaria (which became part of Germany in 1871) in 1812, he arrived in Dayton around 1846, the year of his marriage to Rosina Leopold in Cincinnati. Lebensburger established himself as a "Dealer in Clothing, Gent's Furnishing Goods, &c." In 1850, he brought 12 Jews together to form the Hebrew Society, Dayton's first Jewish organization. Four years later, the Hebrew Society would incorporate as Kehillah Kodesh B'nai Yeshurun (Holy Congregation Children of Righteousness), which would ultimately become Temple Israel. Lebensburger was also an active participant in Dayton's general community. He was a member of a Masonic lodge, the Odd Fellows, Ancient Order of United Workmen, and the Red Men. On Lebensburger's death in 1877 at age 65, the *Dayton Journal* reported, "He was largely known in the vicinity and highly esteemed." The bust of this founder of Dayton's Jewish community sits atop his grave, overlooking Temple Israel's Riverview Cemetery on West Schantz Avenue. (DJO.)

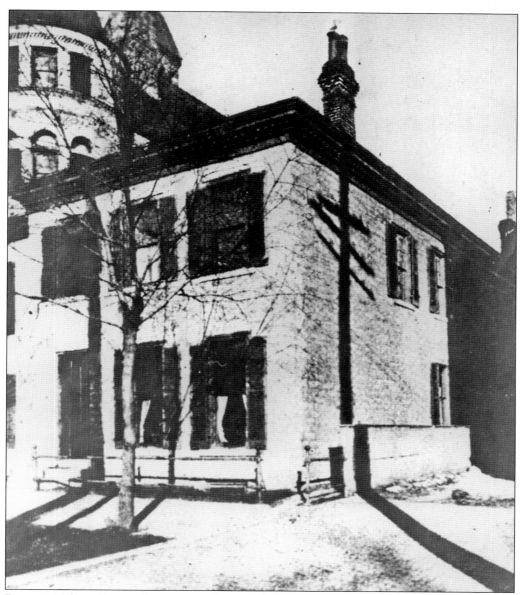

Dayton's Hebrew Society first met on the second floor of this building on the east side of Main Street, south of Water Street (now Monument Avenue). Formerly the Bimm residence, the building had served even earlier as Dayton's first bank. Along with Joseph Lebensburger, the founders of the Hebrew Society in 1850 were Abraham Ach, Philipp Cohn, Henry Herman, Adam Leopold, S. Schab, Elias Schoensberger, Abraham Wendell, and M. Werthaimer. There, they met to pray. The men sat on wooden benches and used a pine wardrobe as the Torah's ark. Also in 1850, the Hebrew Society named Wendell as its "reader." With very few rabbis in America at that time, the reader was the prayer leader, Torah reader, ritual director, and likely even the shochet (ritual slaughterer) for this small group. (DML.)

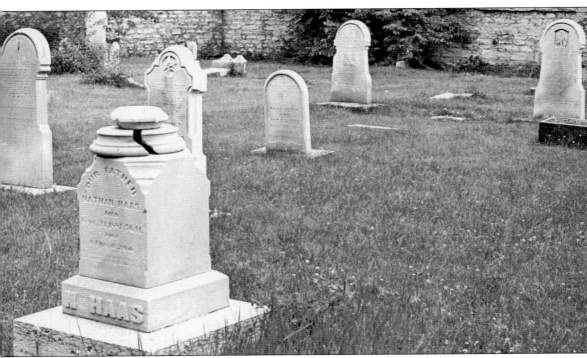

One of the highest priorities of a new Jewish community is to provide a burial site for its members. On July 14, 1851, Joseph Lebensburger purchased a quarter acre of farmland outside the city limits—at Rubicon and Stewart Streets—to serve as the community's first Jewish cemetery, shown here. The first burial there was for seven-year-old Gelinde Friedlich of Piqua in 1852. In 1889, B'nai Yeshurun purchased eight acres on West Schantz Avenue in Van Buren Township when it needed more burial space. This would become Riverview Cemetery. Interments continued at Rubicon and Stewart Streets for another decade. Relatives of those interred at Rubicon and Stewart Streets eventually began moving their graves to Riverview Cemetery, including Joseph Lebensburger's. In 1967, Temple Israel removed and reinterred the remaining graves from its original cemetery. (Temple Israel.)

B'nai Yeshurun dedicated the first synagogue in Dayton on Wednesday, October 7, 1863, at the northeast corner of Fourth and Jefferson Streets. The congregation had purchased the building from a Baptist church for $4,500 and put loving care—and another $2,500—into refurbishing the interior. At 2:00 p.m., a procession made its way from Main Street to the new synagogue. "At the head of the procession was the band; next were the city council, and invited guests," the *Dayton Journal* reported. "Next in order were a large number of pretty little girls, dressed in white, beautifully decorated, and they were marching in couples, then young ladies charmingly costumed, and exquisitely decked with head dresses and scarfs, succeeded them. Then prominent members of the Yeshurun bearing three scrolls, containing the law, covered with the richest velvet cloth, with crowns in decoration, followed under a canopy." The *Dayton Journal* also reported that the congregation had "only some 30-odd" memberships. "Our Hebrew friends here have accomplished a great work in the building up of their beautiful temple of worship," the *Journal* added. (DML.)

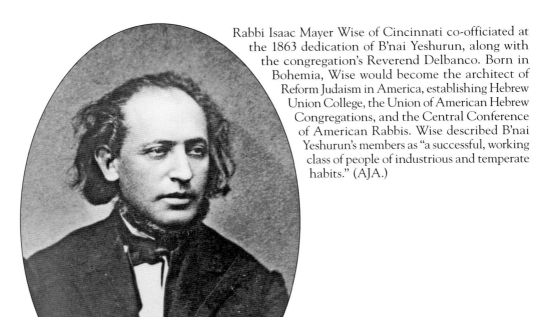

Rabbi Isaac Mayer Wise of Cincinnati co-officiated at the 1863 dedication of B'nai Yeshurun, along with the congregation's Reverend Delbanco. Born in Bohemia, Wise would become the architect of Reform Judaism in America, establishing Hebrew Union College, the Union of American Hebrew Congregations, and the Central Conference of American Rabbis. Wise described B'nai Yeshurun's members as "a successful, working class of people of industrious and temperate habits." (AJA.)

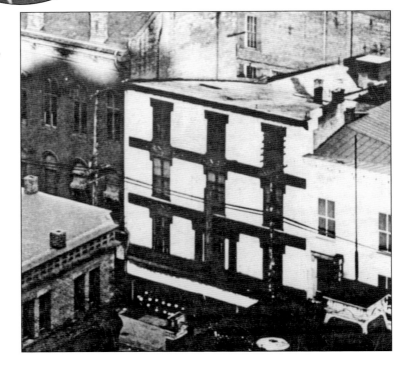

After B'nai Yeshurun's dedication, congregants hosted a ball at Beckel's Hall, a German theater on the east side of Jefferson Street between Third and Fourth Streets. The *Dayton Journal* called it a "brilliant party," with music, dancing, and a "mammoth cake, surmounted by an exquisite bouquet" from D&C Nicum, Central Bakery. The mayor and other prominent citizens attended the ball, which lasted until nearly daybreak. (DML.)

The US Congress bestowed the Medal of Honor on four Jews for their service in the Civil War. Among them was David Urbansky, a private in the US Army's Company B, 58th Ohio Infantry. Urbansky (sometimes spelled Orbansky) was born in Lautenberg, Prussia, in 1843, immigrated to the United States with his parents in 1857, and served in the US Army from October 28, 1861, to January 14, 1865. The reverse side of his Medal of Honor, shown here, indicates that he received it for "Gallantry at Shiloh and Vicksburg." Urbansky was involved in at least 15 fighting engagements in the Civil War and rose to the rank of corporal. After his discharge, he arrived in Piqua with his bride and fresh citizenship papers and established a clothing store there. They had 12 children. He died in 1897. (Both, AJA.)

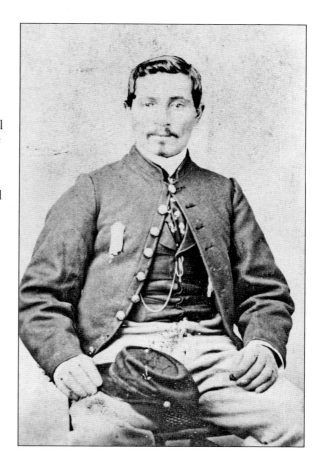

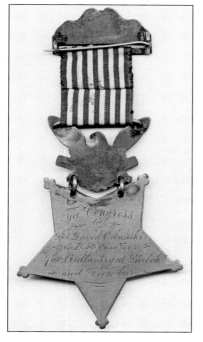

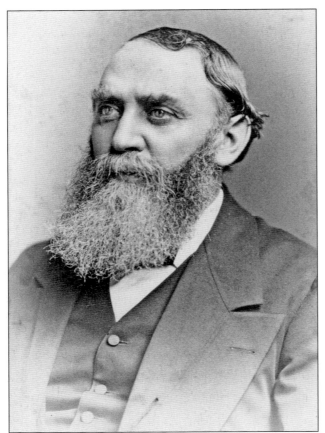

Between 1850 and 1889, B'nai Yeshurun congregation experienced a succession of 10 religious leaders; some claimed to have rabbinic training from Europe, others were men literate enough to lead services. Shown here is the Reverend Ephraim Fischer, a native of Budapest, who served the longest tenure at the congregation during that period, from 1876 to 1881. (AJA.)

With Rabbi Wise in Cincinnati, B'nai Yeshurun incorporated his reforms: Wise's Reform prayer book in 1861, an organ in 1865, the elimination of prayer shawls in 1869, egalitarian seating and a choir in 1875. In 1873, B'nai Yeshurun became a founding member of the Union of American Hebrew Congregations. B'nai Yeshurun dedicated its newly constructed building on the east side of Jefferson Street between First and Second Streets in 1893. (Temple Israel.)

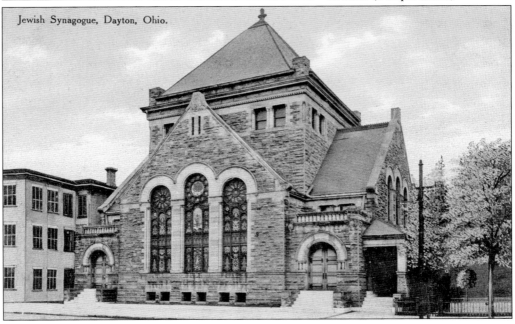

Jewish Synagogue, Dayton, Ohio.

German Jews established the Standard Club in 1883. When the club moved in 1896 to this building at the southwest corner of First and Jefferson Streets—near B'nai Yeshurun—its 50 families enjoyed cotillions, banquets, musical and theatrical programs, and entertainment for out-of-towners, with meals prepared by Dave Goodman. Following three more moves downtown, the club closed in 1925, after Meadowbrook Country Club opened. (Cox Media Group.)

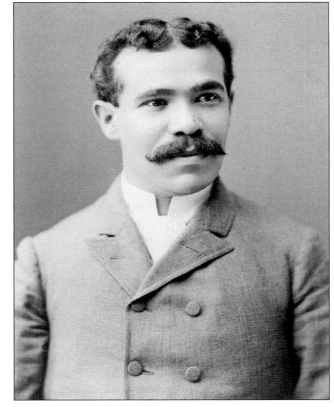

German-born Max Wertheimer was the first rabbi ordained in America to serve B'nai Yeshurun, direct from Rabbi Wise's Hebrew Union College in 1889. However, following the death of his wife, Wertheimer faced a spiritual crisis and left the congregation in 1899 to become a Christian Scientist, then a Baptist lecturer and preacher. His writings on becoming a Christian are still used by organizations seeking to convert Jews. (AJA.)

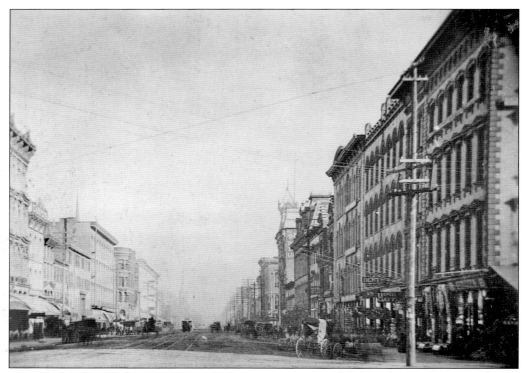

The first known location of Dayton's second synagogue, the House of Jacob, was on the third floor of 20 East Third Street (right, middle of the block) beginning in 1876. B'nai Yeshurun had identified as Reform in 1873; its members who desired traditional worship likely formed this new synagogue. In 1875, House of Jacob trustees Leonard Boutelege, Jacob Wolf, and Julius Wolf paid Elizabeth Rothhaar $200 for less than an acre of land north of Dayton for its cemetery, on Old Troy Road in Mad River Township. House of Jacob then rented space for services near East Third and South St. Clair Streets until Arys Tahl (left), its president in 1887, led the effort to find the synagogue its own building. Six years later, they moved to Wyoming Street. (Above, DML; left, Beth Jacob.)

The great wave of eastern European Jewish immigration to America began in 1881, when anti-Semitic pogroms—organized massacres and violent attacks—spread across the Russian Empire following the assassination of Tzar Alexander II. Though most of these immigrants arrived in New York, Philadelphia, and Baltimore and made their lives there, some spread across America in search of opportunities. These impoverished eastern European Jews—who mainly adhered to Orthodox Judaism—settled in Dayton's East End, along Wayne Avenue. Lithuanian Jews established their own synagogue, House of Abraham, in 1894, to follow customs that were distinct from the Russian Jewish House of Jacob, which had moved to Wyoming Street in 1893. Shown here is the first known location of the House of Abraham; members rented a room at the southeast corner of Fifth Street and Wayne Avenue until 1902. House of Abraham's founders were Sam Behrman, Len Cohn, Isaac Ferst, Charles Frank, A.C. Geshichter, and A. Meyer Jenefsky. Its first rabbi was Mandel D. Friedland. (DML.)

Wayne Avenue was the heart of Dayton's first Jewish neighborhood. The established, acculturated German Jews—successful merchants and professionals—lived downtown in the area of North Robert Boulevard. Their poorer eastern European cousins made their homes in the vicinity of Wayne Avenue between Fifth and Wyoming Streets in the East End. They lived among non-Jewish German immigrants in that neighborhood and even rented the Liederkranz Hall for meetings, Yiddish theater, charity balls, and weddings. Shown here—in a view looking east toward Wayne Avenue—is the Wayne Avenue Market House, 663 Wayne Avenue, where neighbors could buy fruit, vegetables, eggs, and *treyf* (nonkosher) meat. Basketball leagues played on the second floor of the market, where there was a gym. David Samuels sold bread on Wayne Avenue from his horse-drawn wagon, Max Oscherwitz ran a kosher meat market on Burns Avenue, and Max Mann operated his kosher butcher shop on Wayne Avenue across from Hickory Street. The Weinbergs and then the Schneiders ran a kosher bakery known by the 1940s as the Cincinnati Bakery. (DML.)

Two

A New Century

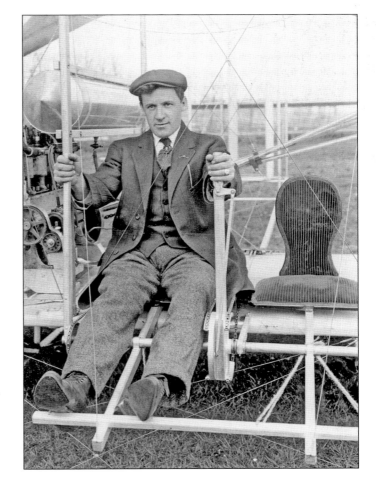

Arthur Welsh sits on a Wright Model B Flyer at Huffman Prairie in 1911. Born in Kiev and raised in Philadelphia and Washington, DC, Welsh is the first known Jewish airplane pilot. He was the first person to learn to fly at the Wright School of Aviation and was a member of the Wright brothers exhibition team. He, his wife, and their daughter lived at 1221 West Grand Avenue. (WBC/WSU.)

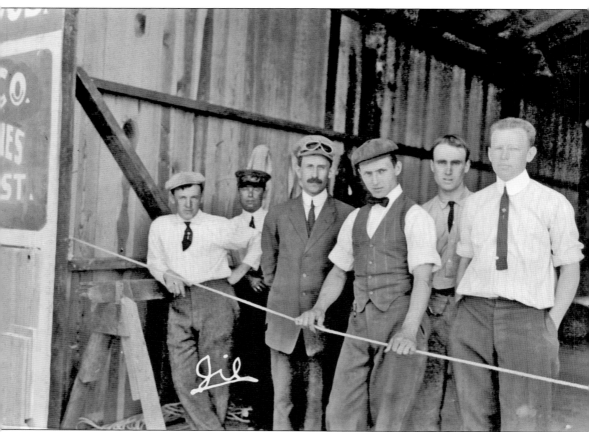

Through sheer persistence, Arthur Welsh (left) persuaded the Wright brothers to hire him for their exhibition division in 1910. Welsh mastered flying from Orville Wright (third from left) and earned a reputation as one of the great flyers and flight instructors of that era. After only two years with the Wright Company, Welsh and a passenger were killed in a crash on June 11, 1912, at College Park, Maryland, during a test flight for the US Army. Welsh left behind his wife, Anna—whom he had met in 1907 at a Zionist Union meeting in Washington, DC—and their two-year-old daughter, Aline. Although this was only two weeks after Wilbur Wright's death of typhoid fever, Orville Wright and his sister, Katharine Wright, attended Welsh's funeral at Adas Israel Congregation in Washington, DC. This image shows the first class of student pilots with the Wright Company in 1910 (left to right), Welsh, Spencer Crane, Wright, Walter Brookins, James Davis, and Archibald Hoxsey. (WBC/WSU.)

Jacob Moskowitz, a Hungarian Jew, brought his talent for establishing foreign labor colonies to Dayton in 1898, when he started a colony of 700 Hungarians on the West Side for the Malleable Iron Works. With Dayton's factories booming, this was a time of labor shortages. In 1906, he opened another Hungarian colony—at Leo and Troy Streets in North Dayton—for the Barney and Smith Car Works. (Curt Dalton.)

Residents of Moskowitz's North Dayton Kossuth Colony, named for a Hungarian hero, saw Moskowitz as a benevolent father; some Dayton leaders believed he exploited his laborers. The colony was self-contained behind a fence, with a church and stores. Workers were paid in tokens for redemption at colony stores. If they bought goods outside the colony that were available for purchase inside, they were dismissed and expelled. (DH.)

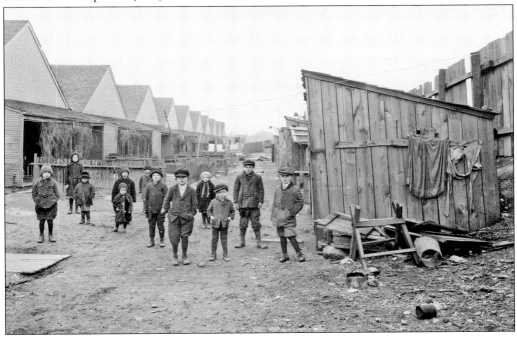

Rabbi David Lefkowitz, who served B'nai Yeshurun from 1900 to 1920, brought together businessmen from his congregation in 1910 to establish the Federation of Jewish Charities of Dayton; it provided impoverished Jews with loans, food, clothing, and coal. He handled the difficult cases. Lefkowitz would serve on the first Dayton NAACP board in 1915 and was the first board chair of Montgomery County's Red Cross in 1917. (DH.)

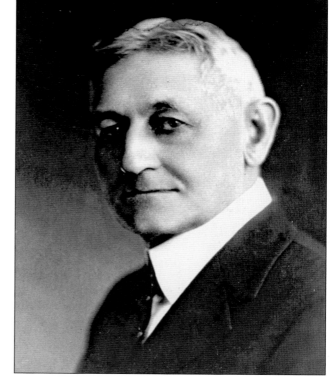

Ferdinand J. Ach, a coffee roaster and purveyor, was the first president of the Federation of Jewish Charities. A member of B'nai Yeshurun, he was temporary chair of Montgomery County's Red Cross before its formal establishment. Other members of B'nai Yeshurun who founded the federation were S. Brown, David Cohen, N. Feinberg, Stanley Krohn, S.G. Kusworm, Harry Lehman, S. Margolis, A.W. Schulman, Joseph Schwartz, and I. Yassenoff. (JFGD/WSU.)

The strangulation and rape of 18-year-old Anna Markowitz at McCabe Park on the night of August 4, 1907, shook Dayton and was covered in newspapers across the United States and overseas. Thousands attended the funeral of this daughter of Polish Jewish immigrants, who was buried at House of Jacob Cemetery. Initially, her sister and two brothers were held on suspicion. (E. W. Scripps Archive, Ohio University Libraries.)

Anna Markowitz's siblings were permitted to leave jail to attend her funeral. With little to go on, the county prosecutor, sheriff, and coroner would sweat a confession out of Layton Hines, a developmentally disabled African American. On trial, Hines recanted his admission of guilt, claiming the officials threatened to send him to the electric chair unless he confessed. Hines was sentenced to life imprisonment. (Cox Media Group.)

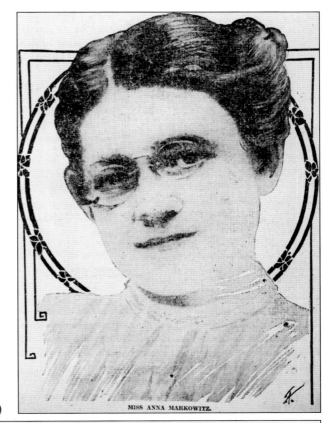

MISS ANNA MARKOWITZ.

THE ONLY PAPER IN DAYTON RECEIVING DOUBLE WIRE ASSOCIATED PRESS SERVICE.

THE DAYTON DAILY NEWS.

LAST EDITION VOL. XX. NO. 299. DAYTON, OHIO, MONDAY, AUGUST 5, 1907. PRICE ONE CENT. 10 Pages

BROTHERS and SISTER HELD ON SUSPICION

Murder of Anna Markowitz Is Shrouded In Mystery and It May Rival the Gilman Case.

Abe Cohan, Who Was Shot, Is Lying In Dangerous Condition at the Hospital.

Abraham Cohan lies at St. Elizabeth hospital in a critical condition. To save his life it will be necessary to operate upon him, as two bullets are supposed to be lodged in the right side of his abdomen.

Cohan is weak from the loss of blood, and at times has been in a semi-conscious condition. He refused to discuss the matter with the authorities who have questioned him, and it was only after a great effort that a statement could be gotten from him at all.

At a late hour Monday morning the injured man had not asked that the hospital authorities notify his family or any of his relatives.

CORONER SCHUSTER TO DAILY NEWS REPORTER.

"I SHALL NOT STATE POSITIVELY THAT THE YOUNG WOMAN WAS CRIMINALLY ASSAULTED. I WOULD WAGER MOST ANYTHING, HOWEVER, THAT SUCH IS THE CASE. I WANT TO BRING ALL OF THIS OUT BY A POST-MORTEM EXAMINATION WHICH I WILL HOLD SOME TIME DURING THE DAY. I HAVE NOT YET SELECTED MY PHYSICIANS. THE FACT THAT THE GIRL WAS CHOKED TO DEATH, AND SHE WAS CHOKED SO THAT HER THROAT HAD SWOLLEN BY THE TIME I REACHED HER AND HAD SOME DIFFICULTY IN REMOVING THE STRING OF BEADS THAT SHE HAD ABOUT HER NECK; THE FURTHER FACT THAT THERE WAS A PLAINLY DISCERNIBLE PATH THROUGH THE HIGH GRASS AND WEEDS, AND EVIDENCE OF A STRUGGLE WHERE THE BODY WAS FOUND, CERTAINLY IS EVIDENCE ENOUGH, HOWEVER, TO SHOW THAT SHE WAS ASSAULTED. WHETHER OR NOT IT WAS BEFORE OR AFTER SHE HAD BEEN STRANGLED I CANNOT SAY. THE POST-MORTEM, HOWEVER, WILL SHOW FULLY."

WHERE ANNA MARKOWITZ MET HER TRAGIC FATE

"Talk to My Sister, She Can Tell You All About It"
—Harry Markowitz.

In a conversation with Deputy Sheriff Odell, Harry Markowitz, the younger of the two brothers detained in the county jail as witnesses in the murder of Anna Markowitz, said: "Why have you got me in here? Why don't you talk to my sister about it? She can tell you all about it."

DOCTORS COMMENCE THE POST-MORTEM

The post-mortem on the body was commenced at 2 o'clock Monday afternoon, at the undertaking establishment of O. P. Boyer's Sons.

Drs. Goodhue, Barker and Hochwalt were selected by Coroner Schuster to hold the post-mortem.

CORONER SCHUSTER CALLS IN DRS. GOODHUE, BARKER AND HOCHWALT TO CONDUCT EXAMINATION.

... around on the girl's body, the coroner did not care to say, although a close examination failed to show anything of this sort before the body was disrobed.

Each piece of clothing was examined carefully as it was removed, ...

25

ONLY NEWSPAPER IN DAYTON RECEIVING DOUBLE WIRE ASSOCIATED PRESS SERVICE.

DAYTON DAILY NEWS

LAST CITY EDITION
Read The News "Want" page every day—and keep in touch with what's doing.

24 PAGES
Washington, May 6—Increasing cloudiness showers late tonight or Saturday, slightly warmer; moderate east winds.

VOL. XXIV. No. 221. DAYTON, OHIO, FRIDAY, MAY 6, 1910. PRICE TWO CENTS. BY CARRIER TEN CENTS A WEEK.

SMITH WHITE CONFESSES FIENDISH ASSAULT ON GIRL IN JEWISH TEMPLE

King Edward VII. Is Dying, All England in Deep Gloom

Monarch's Condition Takes a Sudden Turn and End Is Momentarily Expected.

"WELL, IT IS ALL OVER, I HAVE DONE MY DUTY,"

Probably the Last Words of One of the Most Popular Rulers of the World.

MEMBERS OF ROYALTY

Summoned To the Palace in Expectation of the Final Call. King Stricken Suddenly With Bronchial Trouble—Had Received Diplomats Almost Up To the Hour of Serious Illness, Little Appreciating His Condition.

KING EDWARD

Did White Slay Lizzie Fulhart?

Detectives and Prosecutor Sweat Negro To Throw light on Fate of Girl Whose Body Was Found in Cistern Near Temple.

Colored Man Admits Luring Springfield Girl To Edifice and Outraging Her.

EMPLOYMENT RUSE IS USED IN TRAPPING HIS VICTIM.

Made Her Believe He Would Secure Her Work From a Friend Living Near Church.

WILL PLEAD GUILTY

To Charge Against Him When Arraigned Within the Next Few Days—Authorities Sweat Prisoner for Confession of the Fulhart Murder.

Central American Republic Rocked by Violent 'Quake

Cartago, Ancient Capital of Rica, Practically Destroyed by Seismic Visitation.

ALL HABITABLE HOUSES ARE R...

Dead and Dying Counted by Hundreds, and Terror-Stricken by Thousands.

THE FRIGHTENED POPU...

Rushed To the Street To... Crumbling Buildings, Or Be Swallowed by the Thieves and Murderers From Prison and Add Fears of the People.

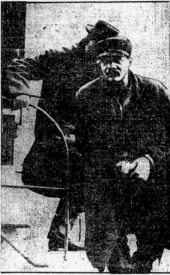

Above is a picture of Smith White, the negro fiend, who has made a full confession of his brutal assault on Bessie Stickford in the Jewish temple.

Before the strangulation and rape of Anna Markowitz, two females in Dayton had met the same fate: 11-year-old Ada Lantz in 1900 and 19-year-old Dona Gilman in 1906. After the Markowitz case, two more would be strangled and raped in Dayton: 18-year-old Lizzie Fulhart sometime between 1908 and 1909, and 15-year-old Mary Forschner in 1909. These four other cases would go unsolved. In his 2015 book *Cold Serial: The Jack The Strangler Murders*, Mary Forschner's great-nephew Brian Forschner makes the case that a serial killer was responsible for all of these brutal murders. He is convinced the serial killer was the janitor at B'nai Yeshurun, Smith White. On February 2, 1910, White lured 25-year-old Bessie Stickford of Springfield to B'nai Yeshurun with the promise of a job interview. He raped her at knifepoint in Rabbi Lefkowitz's study. Exactly a year before, Lizzie Fulhart's corpse was found in a cistern in an alley behind the synagogue. With White's incarceration, Dayton's string of murder-rapes ended. (Cox Media Group.)

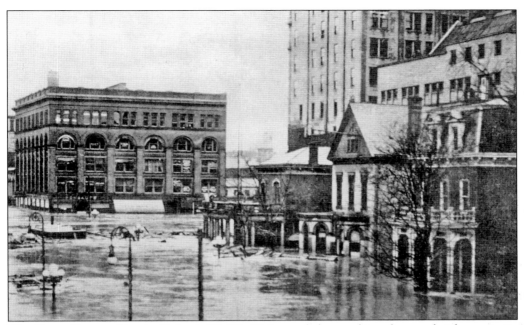

The Great Dayton Flood of March 23–25, 1913—and the resulting fires and sickness in its aftermath—killed more than 360 people and displaced nearly 65,000 from approximately 20,000 homes that were destroyed. In the left of this image is Newsalt's Jewelry Store at the southeast corner of Main and Fourth Streets. The Newsalts would rebuild at the same site. (DML.)

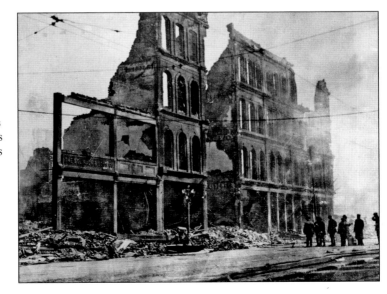

Among the businesses destroyed in the fire after the 1913 flood was Sol Rauh & Sons Company at 107 East Third Street. Rauh, son-in-law of Joseph Lebensburger, rebuilt his wholesale liquor business at the same site. For Jews hit hardest by the flood, the Jewish Federation provided relief loans. By 1915, several borrowers could not repay them, and the federation set aside loans "on which payment would be a hardship." (DML.)

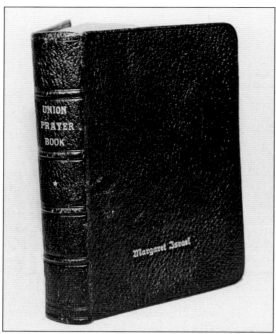

As the waters rose during the Dayton Flood of 1913, the Israel family huddled downtown on the roof and in the attic of their home, 241 Sycamore Street. Parents Margaret and Herman and children Thelma and Henry subsisted on water out of the tank of their toilet, high up on the wall. By the third day, a boat came to their rescue. A source of comfort to Margaret in the attic was the *Union Prayer Book*, in use at B'nai Yeshurun. In the East End, House of Abraham's Rabbi Samuel Burick, his wife, Lillian, and their children were rescued from their home near Richard and Clay Streets by Lillian's uncle, Chaim Shlomo Cohen, whose horse and fruit wagon made so many rescue runs up the Wayne Avenue hill, the horse caught a cold and died. (Both, DJO.)

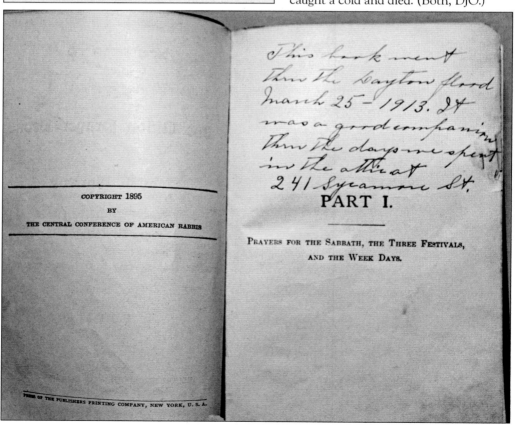

This book went thru the Dayton flood march 25 – 1913. It was a good companion thru the days we spent in the attic at 241 Sycamore St.

COPYRIGHT 1895
BY
THE CENTRAL CONFERENCE OF AMERICAN RABBIS

PRESS OF THE PUBLISHERS PRINTING COMPANY, NEW YORK, U. S. A.

PART I.

PRAYERS FOR THE SABBATH, THE THREE FESTIVALS, AND THE WEEK DAYS.

At the time of the Dayton flood, the House of Abraham worshiped in a small wood-frame building at 530 South Wayne Avenue, which it had purchased in 1902. The 1913 flood destroyed it. Congregants scraped to raise $85,000 and, on August 25, 1918, dedicated a grand new edifice, dubbed the Wayne Avenue Synagogue. As Rabbi Samuel Burick's sons Si and Lee would relate for years after, the synagogue hired Becker's German Band for the dedication. As the musicians marched on Wayne Avenue and approached the synagogue, they broke into "an enthusiastic rendition" of "Onward, Christian Soldiers." (Both, Beth Abraham Synagogue.)

· 1894 ·

Programme
of

Dedication

Wayne Avenue Synagogue
Dayton, Ohio

K. K. House of Abraham
Congregation

Sunday, August twenty-fifth
at 2:00 P. M.

Maximilian K. Margolis
Chairman

· 1918 ·

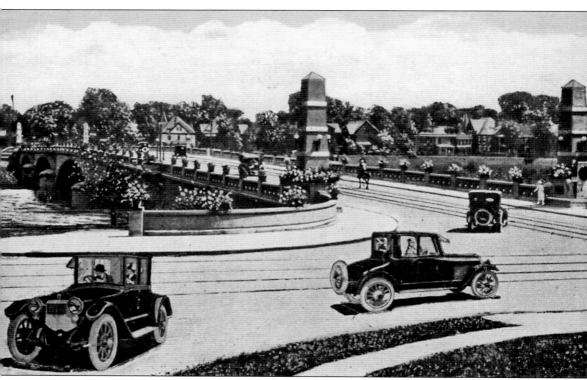

After the trauma of the 1913 flood, which crested as high as 20 feet downtown, Daytonians with the means to do so moved to upscale communities on high ground such as Oakwood and across the Miami River to Dayton View. Jews, however, were generally prohibited from living in Oakwood through discriminatory real estate restrictions. This led to the Jewish community's gradual migration to Dayton View, shown here from the Dayton View Bridge. The first synagogue in this neighborhood was the Dayton View Synagogue Center, also the city's first Conservative Jewish congregation, organized in 1922 and incorporated in 1924 at 225 Cambridge Avenue. At first, it was formed as an educational institution. The founders of Dayton View Synagogue Center included Nathan Factor, Samuel Finn, Rose Friedlob, Harry Katz, J.I. Leventhall, V. Lieberman, R. Lustig, John Matusoff, H.L. Miller, A.L. Pierce, A.B. Saeks, Dorothea Saeks, M.E. Saeks, Jacob Siegal, Philip Sokol, Eva Spaier, Sadie Tanis, and Minnie Wolfson. Over the next two decades, Dayton View would become Dayton's next Jewish neighborhood. (DML.)

Three

MERCHANTS

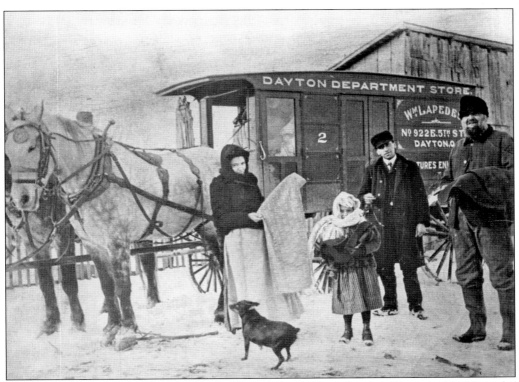

William Lapedes (next to the wagon) sells fabric to the Godown family in Eaton in 1905. Lapedes would establish the Lion Store, a men's clothing shop, on Jefferson Street. Lion is now one of the world's leading suppliers of firefighting clothing. Still family-owned and based in Dayton, Lion produces protective equipment and training facilities for emergency services and first responders. (Lion Group Inc.)

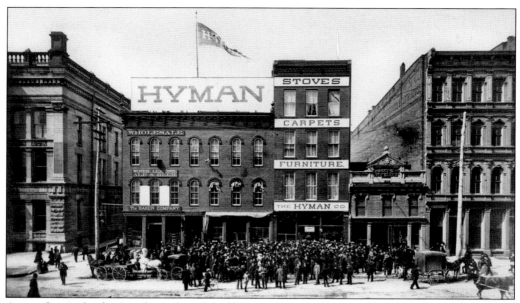

A crowd waits for the grand opening of the Hyman Company Store at 29 and 31 North Main Street in 1893. The president of the store was David W. Hyman, who had expanded his operations from Cincinnati. The company billed itself as "dealers in furniture, carpets, stoves, general household goods, clothing, clocks, dress goods, jewelry, etc." (DML.)

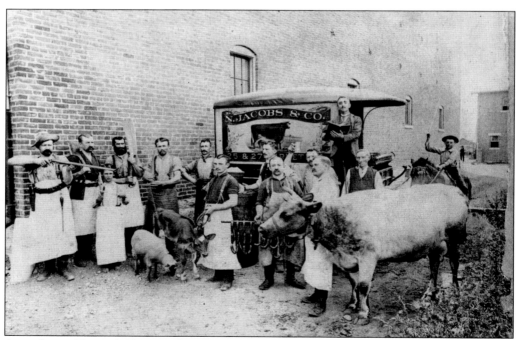

According to Dayton's 1880 city directory, N&C Jacobs & Company were commission merchants, dealers in livestock, and "all kinds of meat," located at 25 and 27 Market. Would this have been a kosher enterprise? Maybe the gent with the rifle is just posing for the camera. (AJA.)

Sarah and Adolph Newsalt rebuilt their jewelry store at Main and Fourth Streets after the Great Dayton Flood of 1913. In the 1909 *History of the City of Dayton and Montgomery County, Volume 2*, the Rev. Augustus Waldo Drury writes, "Today, Mr. Newsalt is one of the foremost representatives of the jewelry trade not only in Dayton but in the state of Ohio and has many patrons throughout the surrounding country and as far west as St. Louis." Sarah died in 1922. Adolph worked at his business for 57 years, until a week before his death in 1927 at the age of 74. (Both, AJA.)

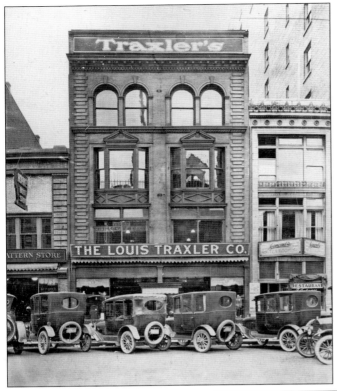

The Louis Traxler Company dry goods building at 31 and 33 South Main Street, one of Dayton's largest department stores, survived the 1913 flood. Born in Austria in 1865, Louis Traxler opened his first store in Dayton in 1899 at the northwest corner of Fifth and Main Streets. He served as an early president of the Federation of Jewish Charities in Dayton. Traxler introduced a program in 1913 to pay the tuition for his female employees to enroll in domestic, art, or business courses at the YWCA. By the end of that year, 60 of Traxler's employees had signed up. In 1922, Traxler's moved to Fourth and Main Streets. (Left, DML; below, JFGD/WSU.)

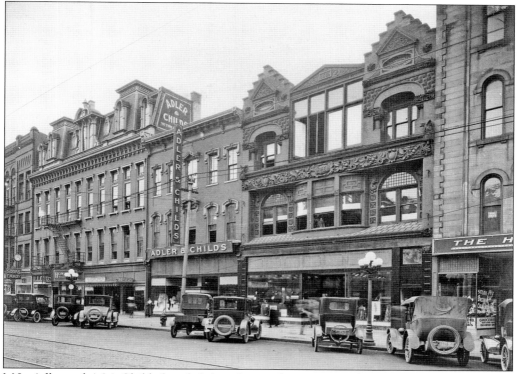

M.L. Adler and A.M. Childs founded their dry goods store in 1895 at 24 East Third Street with seven employees. On February 6, 1922, the store's semiannual Loom End Sale broke Dayton's retail sales records; an estimated 75,000 people—the largest crowd recorded in Dayton—arrived and made more than 30,000 purchases. Management summoned police to help the store's hundreds of clerks keep order. (DML.)

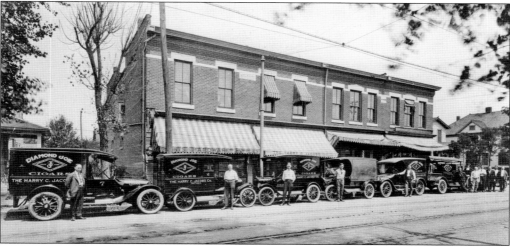

At age 17, with $35 worth of cigars, Harry C. Jacobs started his wholesale cigar business in 1893. Shown here in 1920, his sales force stands in front of their delivery cars at the Harry C. Jacobs Company, 2927 East Third Street. The company used horses and wagons for deliveries until 1914. (AJA.)

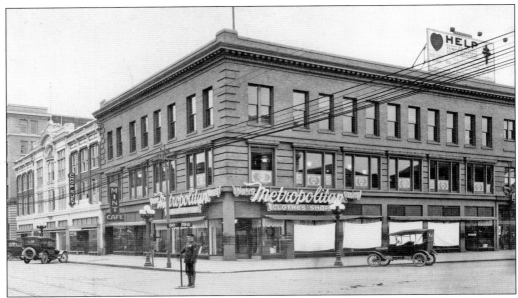

J.H. Margolis founded the Metropolitan Clothing Company at Fourth and Ludlow Streets in 1913 when he was 26, after his Harvard Store at Fifth and Jefferson Streets was destroyed in the Great Dayton Flood. An immigrant from Poland, Margolis arrived in Dayton at age 15 and learned the trade working at his uncle Sam Margolis's Fair Store. The Metropolitan men's clothing store's slogan was, "If our clothes don't make good—we will." Eventually, the Metropolitan expanded to include a boys department, university shop, a military section during World War II, and ladies' ready-to-wear clothing. After J.H. Margolis died at 53 in 1940, his brother David led the business, followed by J.H.'s sons Bob and Jack. (Above, DML; below, Margolis Family.)

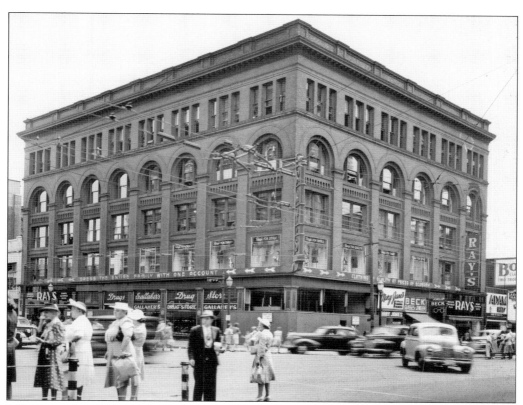

"Clothing of quality at prices of economy" was a slogan for Ray's department store, at the southeast corner of Fourth and Main Streets. Ray's founder, Philip Sokol, arrived from Russia at age 21. He started in business with $12, enough to buy a suitcase and some "soft goods" to sell door-to-door. Sokol opened his first apparel store, the Model, in 1916 and then merged it with Ray's, which he opened in 1921. Sokol was one of the founders of the Dayton View Synagogue and served as chair of Dayton's United Jewish Campaign. He was later joined in the business by his son Boris F. Sokol, who would also serve as United Jewish Campaign chair and as president of the Jewish Federation of Greater Dayton. (Above, Shelly Charles; right, JFGD/WSU.)

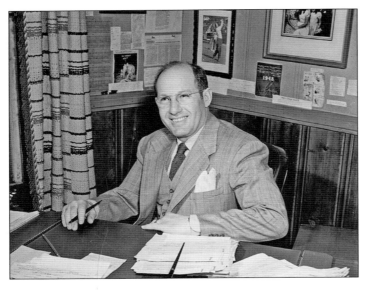

After his father, Abe, died in 1935, Herbert Orby Schear became president of Liberal Markets. He, his two sisters, and five younger brothers had worked in the grocery business since childhood with their parents, Abe and Sarah, émigrés from Lithuania and Latvia, respectively. Abe Schear started as a peddler, eventually bought a produce truck, and opened his first store in the 1920s at Third Street and Linden Avenue. (DDN/WSU.)

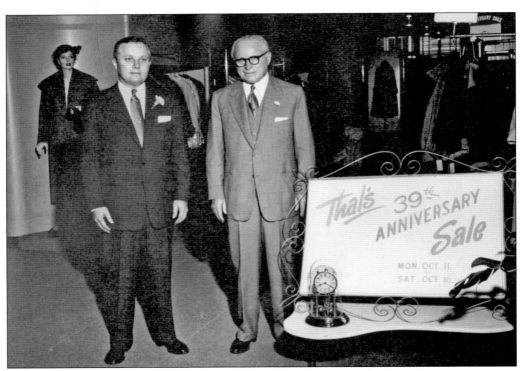

Joseph Thal (right) and his son Norman prepare to greet customers at the Joseph Thal Company store at 17–19 South Main Street in 1958. Joseph Thal established his women's clothing store in 1919. In 1934, he became the first chair of Dayton's United Jewish Campaign. His brother Sam Thal, who established Rogers and Company Jewelers in 1922, was president of the Jewish Federation in the 1930s. (DDN/WSU.)

Jacob A. Donenfeld, a native of Austria, worked his way up at Rike-Kumler's for 13 years before he opened his own store for women in 1924 at 35 and 37 North Main Street. When he died of a heart attack at age 50 in 1936, his wife, Sadie, ran the store. Sadie was also an early president of Dayton's Hadassah chapter. (Andrea Grimes.)

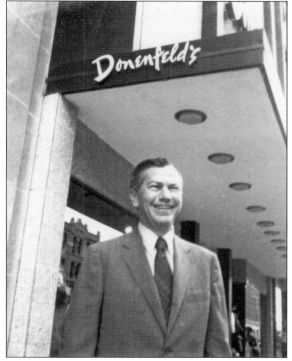

When Sadie Donenfeld's husband died, their sons Ralph and Stanley were still teenagers. After they returned from their service in World War II, Ralph and Stanley led Donenfeld's, ultimately expanding to the suburbs, in the Dayton and Salem malls. Shown here is Stanley Donenfeld in front of the downtown store. (Andrea Grimes.)

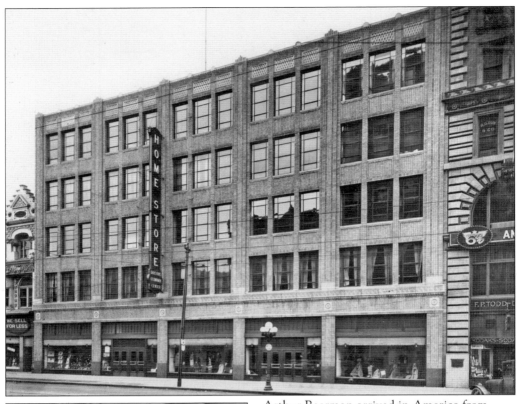

Arthur Beerman arrived in America from Lithuania at age 10 and came to Dayton at 22 in 1930 to work for the Home Store at 8 East Third Street. In 1956, he bought the Home Store and renamed it Beerman Stores. In between, he opened his Cotton Shops in several Dayton neighborhoods and formed Beerman Realty, with confidence that the future of retail was in the suburbs. In 1961, Beerman acquired a controlling interest in Elder & Johnson—which dated to 1883—and in 1962, he merged Beerman Stores with Elder & Johnson to form Elder-Beerman Stores. A year before he died, in 1969, he established the Beerman Annual Thanksgiving Day Dinner, which provided free Thanksgiving dinners at a community meal for those in need. (Above, DML; left, DDN/WSU.)

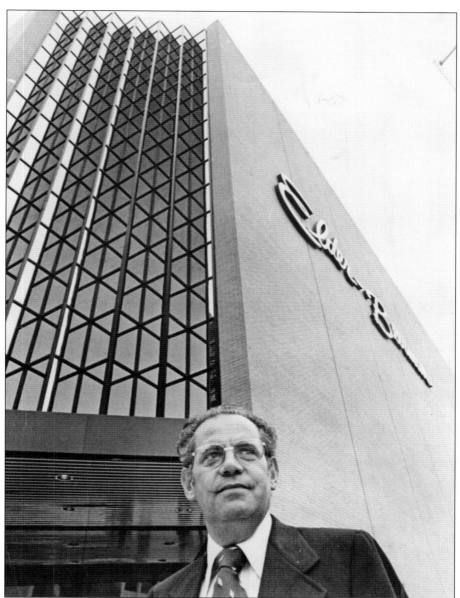

When Arthur Beerman died in 1970 at age 62, Max Gutmann became chairman and CEO of Elder-Beerman Stores. Gutmann and his family fled Nazi Germany in the wake of Kristallnacht (the Night of Broken Glass) in 1938. They found refuge in Shanghai. After serving in US Army Intelligence from 1943 to 1946, Gutmann ran the leased shoe department at Adler and Childs. In 1953, he and Beerman became partners in the Bee Gee Shoe Corporation, which operated leased shoe departments in Beerman Stores. They eventually opened freestanding El-Bee Shoe Outlets and Shoebilee! stores. Gutmann significantly expanded the Elder-Beerman chain and acquired several regional department stores and chains across the United States for Elder-Beerman. Although Gutmann retired from Elder-Beerman in 1991, he returned in 1995 to help turn the company around after it filed for Chapter 11 reorganization. Gutmann was a founder of the Downtown Dayton Partnership and the Dayton Development Council. (DDN/WSU.)

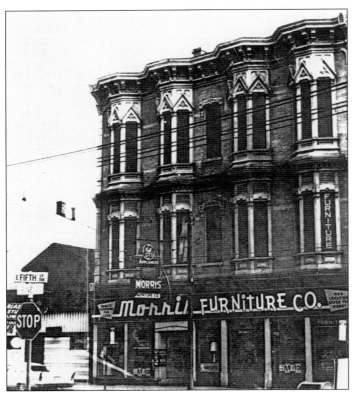

Morris Lieberman, a furniture-store salesman and manager (shown here with his wife, Sadie) opened his own used furniture store, Morris Furniture Company, in 1947 at 444 East Fifth Street. Lieberman was born in Russia and raised in the heart of Dayton's East End Jewish neighborhood. He was joined in the business by his son, Bert, who had returned from the Philippines, where he was stationed at the end of World War II. Eventually, they sold new furniture, and in 1998, Bert Lieberman's son-in-law Larry Klaben bought the family business, which he expanded to stores in the Cincinnati, northern Kentucky, and Columbus markets. (Both, Marilyn Klaben.)

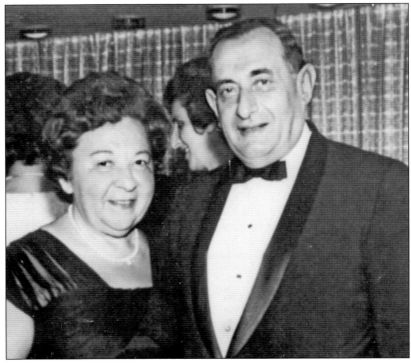

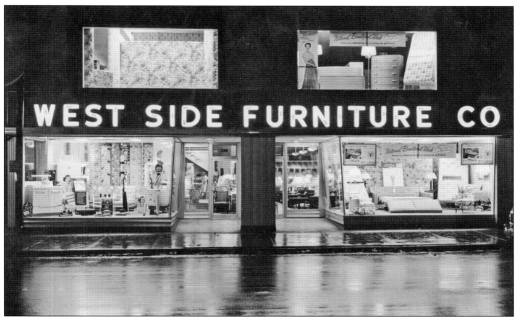

In 1911, Lester Kusworm (below, left) opened West Side Furniture Company at 1124 West Third Street, across the street from the shop where the Wright brothers developed their first airplane a decade before. Kusworm's son-in-law Lester Emoff (below, right) would join the business, as would Lester Emoff's son Robert. Even through the devastating West Side riots of 1966 and 1967, the family continued to operate the business there in addition to two other stores. In 1975, three men kidnapped Lester Emoff, extorted the family, and killed him after receiving the ransom. One of the kidnappers was a former deliveryman for the company. (Both, Michael Emoff.)

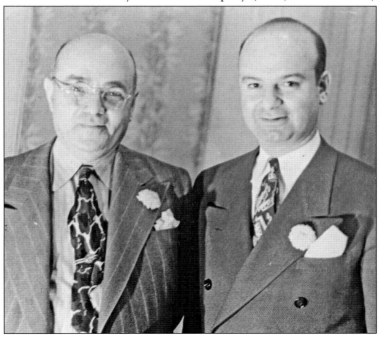

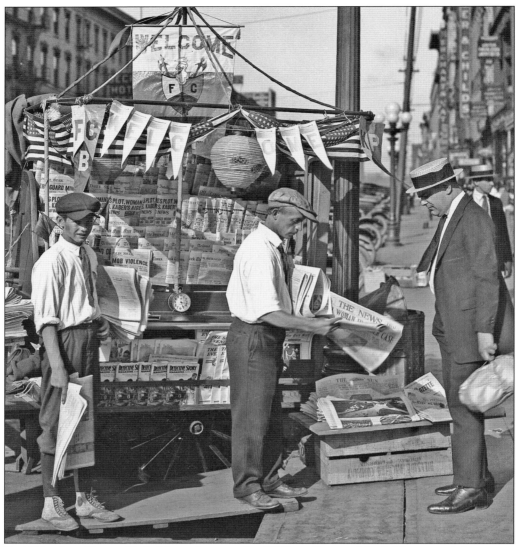

By 1921, when *Dayton Daily News* photographer William Preston Mayfield captured this image on Third Street, enough Jews worked and shopped in downtown Dayton for this newsstand to stock Yiddish newspapers (below the Chinese lantern). Dayton's population of 152,559 in 1920 included an estimated 5,000 Jews. In 1912, Dayton's Federation of Jewish Charities had entered an agreement with the Industrial Removal Office in New York to settle eight Jewish immigrant cases a month: six individuals and two families. The project attempted to ease the glut of eastern European Jewish immigrants languishing on New York's Lower East Side. Each month, until World War I obstructed immigration, Dayton's Jewish Federation would inform the Industrial Removal Office of jobs available in Dayton and the skills they required. After the war, the Emergency Quota Act of 1921 and the Immigration Quota Act of 1924—overwhelmingly passed by the US Congress—slashed the annual number of émigrés from southern and eastern Europe allowed into the United States by 87 percent. Jewish immigration to the United States went down to a trickle. (DH.)

Four

HOLY CONGREGATIONS

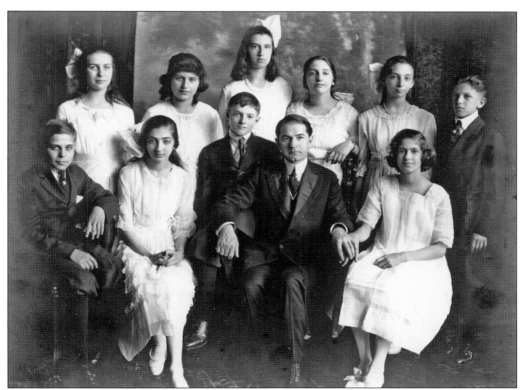

After 20 years with B'nai Yeshurun, Rabbi David Lefkowitz, shown with his 1920 confirmation class (including his daughter, Helen, right), departed Dayton that year for Dallas. In a University of North Texas dissertation titled "Rabbi David Lefkowitz of Dallas," Jane Bock Guzman writes, "Dayton civic leaders tried hard to persuade him to remain, and 47 non-Jews even offered to join his congregation if he would stay." (Temple Israel.)

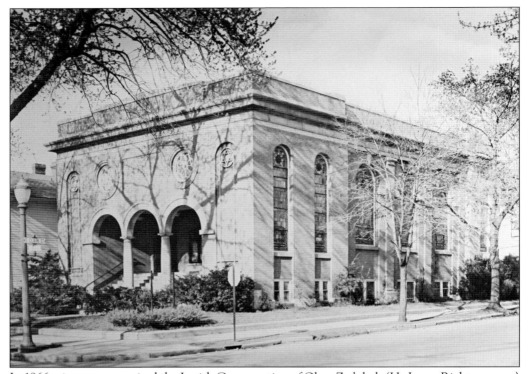

In 1866, nine men organized the Jewish Congregation of Ohev Zedukah (He Loves Righteousness) in Springfield. The congregation held services in rented spaces for its first half century. Ohev Zedukah identified with the Reform movement in 1873, changed its name to Temple Sholom, and called this building at South Fountain Avenue its home from 1918 to 1959, before it moved to North Limestone Street. (Temple Sholom.)

Jews in the Piqua area established Temple Anshe Emeth (People of Truth) in 1858, holding services at Moses Friedlich's home. The temple identified as Reform in 1873 and moved to its present location on Caldwell Street in 1923. Leo M. Flesh, president of Piqua's Atlas Underwear Company, was the major donor for the building. Though he was not a practicing Jew, Flesh, who was born in Piqua, had Jewish lineage. (DJO.)

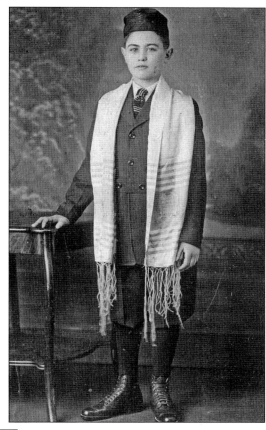

Life can be rough for children of clergy, growing up in full view of congregants, but Lee Burick looks every bit the prepared bar mitzvah boy in this 1924 portrait (right). His father, Rabbi Samuel Burick (shown below in later years), served the House of Abraham synagogue from his arrival in 1906 until 1949. Rabbi Burick's son Si would become a longtime sports writer and editor for the *Dayton Daily News*. In one 1971 column, Si wrote that in the early years, when the synagogue was on Wayne Avenue, Rabbi Burick was "a preacher, teacher, prayer leader, cantor, marrier, circumciser, kosher slaughterer, marriage counselor, burier, occasional divorcer and fund raiser. A modern spiritual leader would collapse under the load; to this Polish-Russian immigrant, this was a way of life." (Both, Lawrence Burick.)

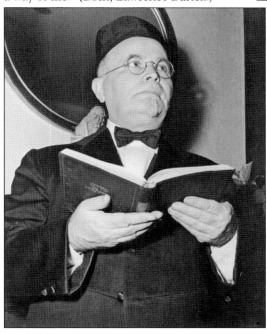

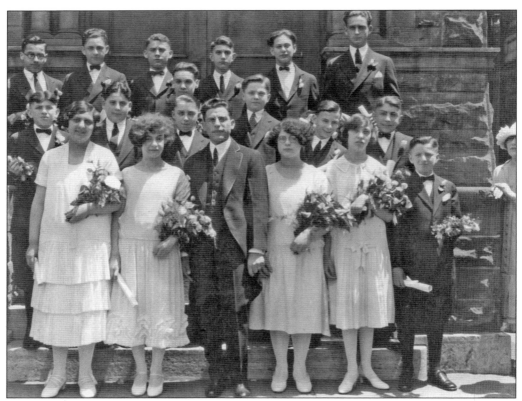

Rabbi Samuel S. Mayerberg, shown above with a confirmation class on the steps of B'nai Yeshurun's building at Jefferson between First and Second Streets, continued the temple's tradition of championing social reform in the general community. Mayerberg railed publicly against Dayton's Ku Klux Klan, which by 1924 had at least 15,000 members and burned crosses in black, Jewish, and Catholic neighborhoods with frequency. In 1922, Mayerberg headed a protest that kept the Klan from renting Memorial Hall. With the expansion of the temple to 200 families during his tenure and the Jewish community's continuing migration to Dayton View, Mayerberg led the congregation's move to a new "community house" building (below), at the corner of Salem and Emerson Avenues in 1927, before his departure. With the move, B'nai Yeshurun changed its name to Temple Israel. (Both, Temple Israel.)

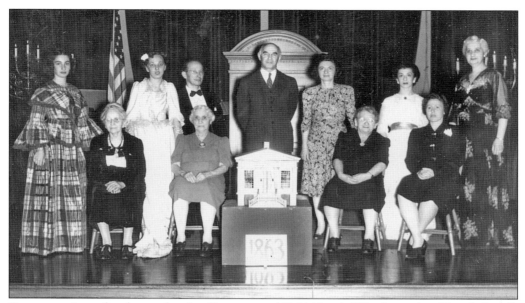

Representatives of early member families surround Rabbi Louis Witt (center) at Temple Israel's 85th anniversary in 1935, complete with a model of its first building. Rabbi Witt expanded the temple's interfaith efforts, establishing its annual Institute on Judaism, which taught local Christian clergy about Judaism. His controversial encouragement of Jews to celebrate Christmas "in the spirit, not in the theology," made national news. (Temple Israel.)

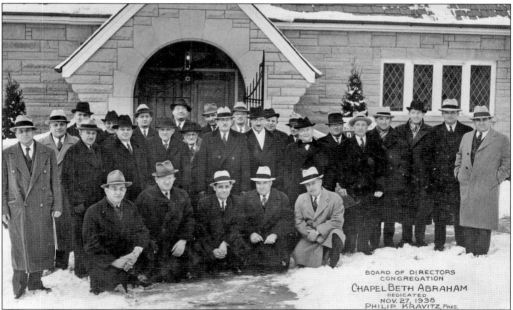

In 1938, Beth Abraham Synagogue dedicated its cemetery chapel. In 1894, Beth Abraham purchased the land for its cemetery, just west of Temple Israel's Riverview Cemetery on West Schantz Avenue in Van Buren Township. When Riverview Cemetery purchased additional adjacent land in Oakwood in 1953, Jews were mainly restricted from living in Oakwood. A bitter joke arose: Jews could move to Oakwood if they were dead. (Beth Abraham.)

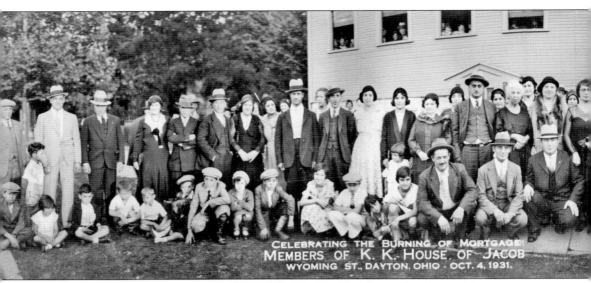

CELEBRATING THE BURNING OF MORTGAGE
MEMBERS OF K. K. HOUSE OF JACOB
WYOMING ST., DAYTON, OHIO · OCT. 4, 1931.

At sunset on October 4, 1931, members of the House of Jacob posed in front of their synagogue, at 358 East Wyoming Street, to celebrate the burning of the building's mortgage. The House of Jacob moved there, at the foot of Woodland Cemetery, in 1893 with Philip Weisman as its rabbi. At the time, the city's water supply did not reach beyond Alberta Street; congregants had to carry

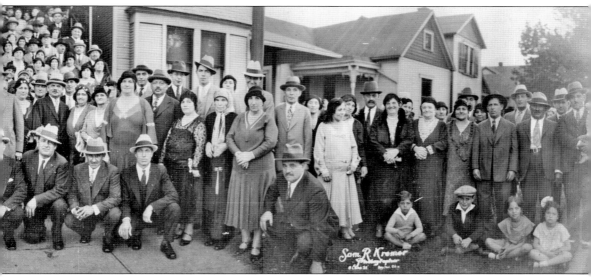

water from a nearby well. Rabbi Mendel Finkelstein became House of Jacob's rabbi in 1899, and with the exception of 1903 to 1904—when Rabbi Weisman was hired back for a season—Rabbi Finkelstein continued on with House of Jacob until his retirement in 1939. (Beth Jacob.)

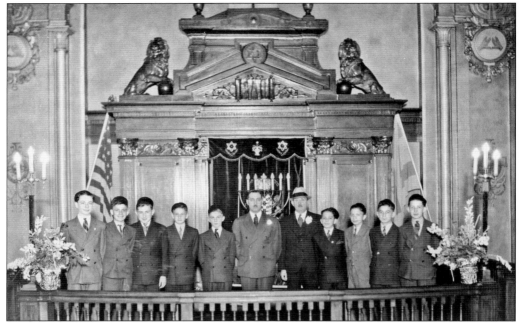

Standing on the *bima* (stage) of Beth Abraham Synagogue on Wayne Avenue is the bar mitzvah class of 1936–1937. From left to right are Solomon Fishkin, Robert Rosichan, Arnold Patterson, Gerald Wilks, Albert Levitt, Rabbi Irving Meisel, Philip Kravitz, Arthur Carne, Joseph Kantor, Seymour Wilks, and Nathan Kipner. Note the Zionist flag, in support of a Jewish state, displayed to the right of the ark. (Arthur Carne.)

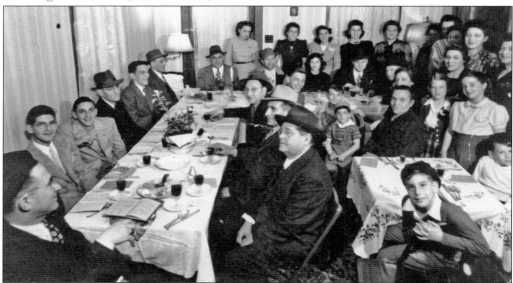

Among the six men who founded Beth Abraham Synagogue in 1894 was peddler A. Meyer Jenefsky, seated to the left of the lamp at this family Passover Seder in 1945. In 1904, Meyer established a wholesale fruit business. Russian-born Meyer and his wife, Tillie, raised nine daughters and five sons; all survived into adulthood, a rarity in an age of high infant mortality rates. (Gerald Jacobson.)

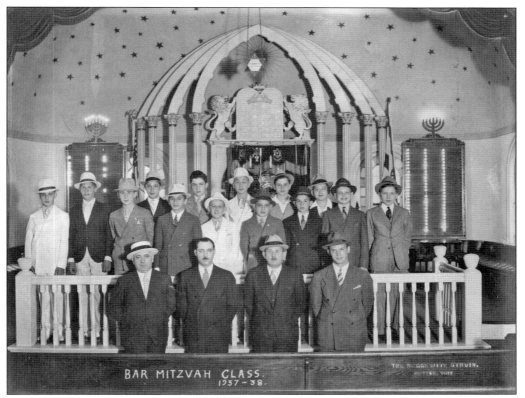

Shown on the bima at Beth Jacob Synagogue is the combined Beth Abraham/Beth Jacob bar mitzvah class of 1937–1938. From left to right are (first row) Menashe Friedman, Rabbi Irving Maisel, Philip Kravitz, and unidentified; (second row) Ben Weinstein, Bernard Maybruck, Al Solkov, Al Eslow, Gilbert Unger, Hank Saeks, Herman Ellison, Arnold Patterson, Martin Abromowitz, Marvin Jenefsky, Ted Levitt, Irv Jacobson, Hank DeLott, and Elwood Kaplan. (Beth Abraham.)

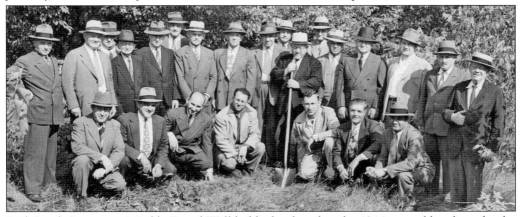

Beth Jacob Synagogue's Rabbi David Well holds the shovel at the 1944 ground breaking for the congregation's new building at 1350 Kumler Avenue in Dayton View. Although Beth Jacob initially agreed in 1942 to merge with Beth Abraham Synagogue and Dayton View Synagogue to form the United Congregations of Dayton, Beth Jacob changed course when it became apparent the new entity would not maintain Orthodoxy. (Beth Jacob.)

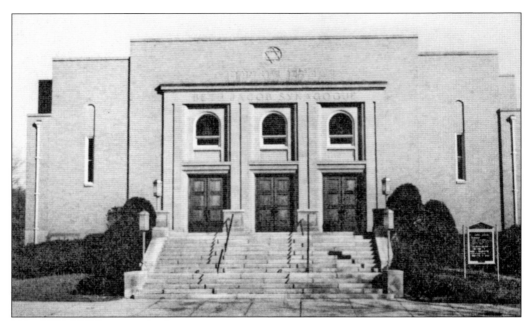

Beth Jacob Synagogue dedicated its new building on Kumler Avenue on August 26, 1945, with representatives and rabbis from Dayton's other synagogues in attendance, as well as Dayton mayor Frank Krebs, who addressed the congregation. It also held its first donor dinner that year (below), organized by, from left to right, Anna Degan, Ben Dlott, Mollie Mayerson, Louis and Mollie Donoff, Anna Dlott, Minnette Cohen, Julius and Esther Donoff, and Esther and Menashe Friedman. Along with its new home, Beth Jacob hired Rabbi Benjamin Lapidus, who served the congregation until 1954. Over this period, the congregation doubled in size to 400 memberships and its religious school grew from 25 students to more than 180. (Both, Beth Jacob.)

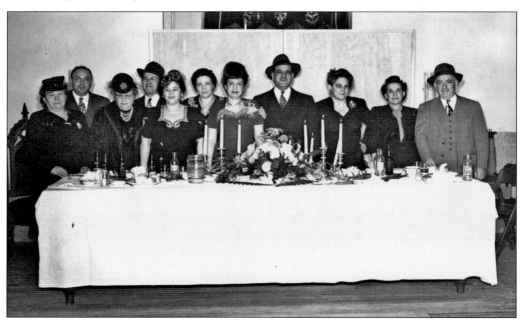

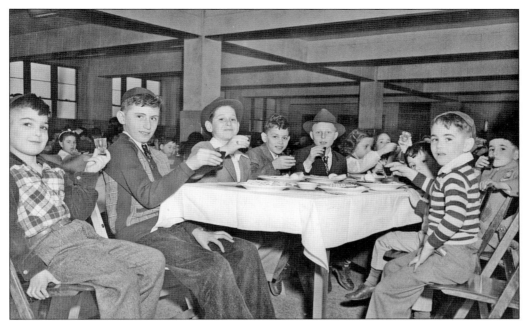

Students with the Dayton Hebrew Institute, Beth Abraham United Synagogue Center, Beth Jacob Synagogue, and Temple Israel participate in a community model Passover Seder at Beth Jacob Synagogue on March 30, 1947. Were these children making Kiddush over grape juice or wine? The answer is lost to history. (JFGD/WSU.)

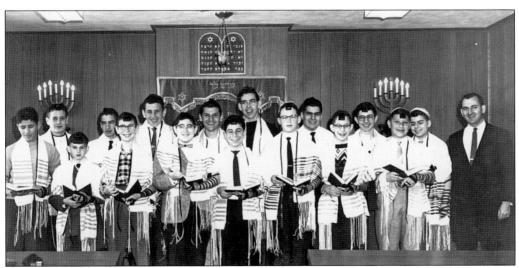

Beth Jacob Synagogue hired Samuel Fox (right) in 1955 as its rabbi. Born in Lokatch, Poland, and raised in Milwaukee, Rabbi Fox received rabbinic ordination from Hebrew Theological College in Chicago and a law degree from DePaul University. He and his wife, Miriam, championed the reestablishment of a *mikveh* (ritual bath) in Dayton, and the founding of a Jewish day school. (Beth Jacob.)

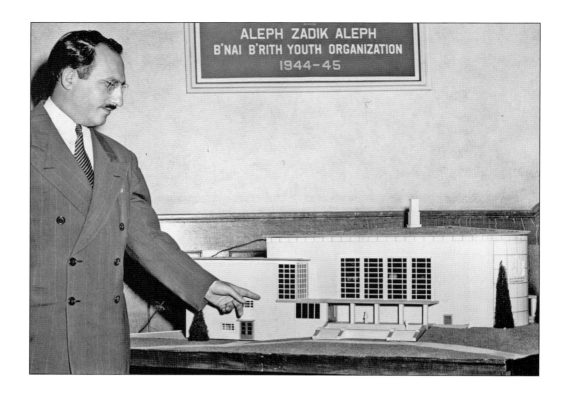

Rabbi Jacob B. Agus (above) was hired in 1942 to lead what would become Beth Abraham United Synagogue, the merger of Beth Abraham and Dayton View Synagogues. BAU as it was called, identified with Conservative Judaism. Born in Poland in 1911, Rabbi Agus was ordained at Yeshiva University. In 1945, he joined the Conservative movement's Rabbinical Assembly and would become an important theologian in the movement. Locally, his sermons were often broadcast on WHIO-AM. Here, he points to a model of the synagogue's new building at Salem Avenue and Cornell Drive in Dayton View. The dedication of the synagogue's cornerstone (below) was held May 2, 1948, and the building was dedicated September 18, 1949. Behind the synagogue's beams is the Mearick mansion, which was remodeled as the Dayton Hebrew Institute's home. (Above, DDN/WSU; below, Beth Abraham.)

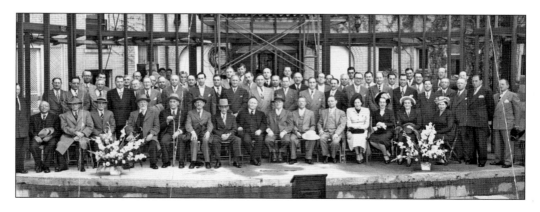

When Beth Abraham United Synagogue was dedicated, only two of its eight 16-foot-high stained-glass windows were installed. Artist Todros Geller designed the High Holy Days and Sabbath windows, the two closest to the ark. After Geller died, A. Raymond Katz designed the remaining six in the same style, depicting Judaism's major holidays. With the dedication of the new synagogue little more than a year after Israel's establishment, the window here is notable: it depicts the new holiday of Yom Haatzmaut, Israel Independence Day. The circular panel at the top illustrates Amos 9:15: "And I shall plant them once again on their soil." The square panel at the bottom shows a laborer and a scholar blending their efforts, rewarded by the vision of Jerusalem restored, fulfilling Isaiah 2:3: "For out of Zion shall go forth the Law, and the word of the Lord from Jerusalem." Images at the very top depict modern housing in Israel, refugees disembarking a ship into Israel, and a watchtower to symbolize the return to the soil. (Beth Abraham.)

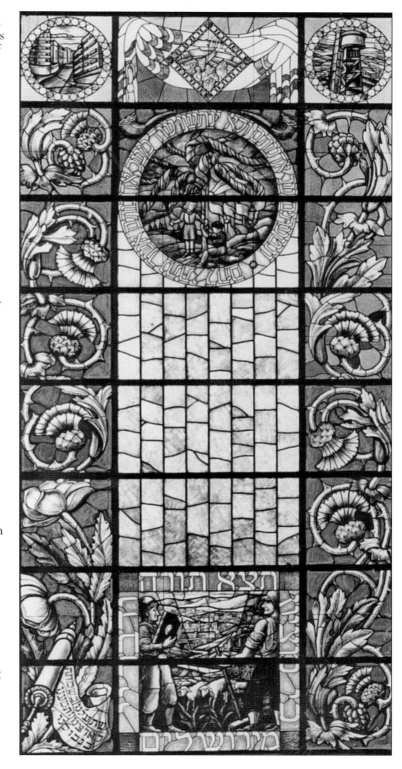

Temple Beth Sholom (House of Peace) in Middletown moved to its new home on Gladys Drive in 1955 with 100 memberships. Ten Orthodox families founded the synagogue in 1903 in a rented room on Clinton Street. In 1915, the congregation bought a building on First Avenue. Soon after, it incorporated as Anshe Sholom Yehudah Congregation (Judah, People of Peace). By 1940, it identified as Conservative, and later as Reform. (DJO.)

Leaders of Piqua's Temple Anshe Emeth dedicated a new Torah scroll in 1958. Shown here (left to right) are Vice Pres. Sam Kastner, Pres. Joe Shuchat, a student rabbi, and Irv Lubell. In 1958, the temple also completed construction on its social hall and kitchen, which serves as a community center. It was also the meeting place for Piqua's B'nai B'rith Lodge 1523, founded in 1944. (Anshe Emeth.)

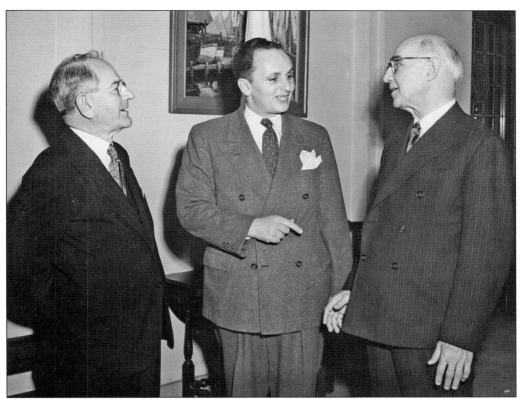

Following Rabbi Louis Witt's (right) retirement in 1947, Rabbi Selwyn D. Ruslander (center) became Temple Israel's spiritual leader. A Navy chaplain in World War II, Rabbi Ruslander was the first Jewish chaplain in the Navy assigned to a combat fleet; he was a flotilla chaplain during the invasion of southern France. Over his tenure, until his death in 1969, Rabbi Ruslander nudged Temple Israel toward more traditional aspects of Judaism: the return of bar mitzvahs, a cantor, Hebrew classes, and the addition of bat mitzvahs. He was also a founder of the Dayton Urban League. Pictured with Rabbis Ruslander and Witt is Rabbi David Lefkowitz (left), most likely at the temple's 1950 centennial celebration. At more than 500 memberships and growing, Temple Israel added a sanctuary building (below) to its campus in 1953. (Both, Temple Israel.)

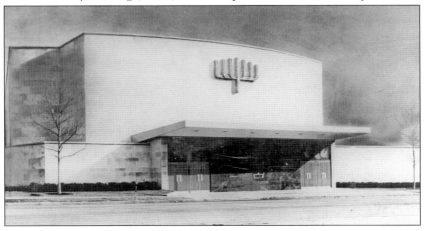

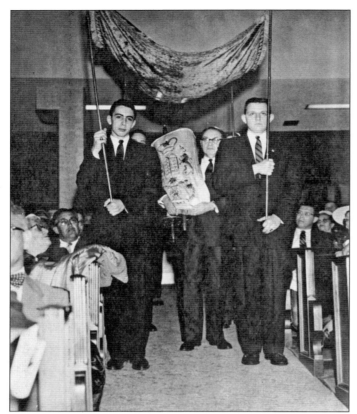

In 1956, Beth Abraham United dedicated a Torah comprising 33 fragments of Torahs retrieved from Nazi Europe, painstakingly reassembled by the Israeli Ministry of Religion. Philip Sokol carried the Torah into the sanctuary; his Israeli cousin, Eliahu Shklovsky, obtained Israeli prime minister David Ben-Gurion's permission for the scroll to be shipped to Dayton. Congregants of all ages raised funds for the scroll's restoration. (Beth Abraham.)

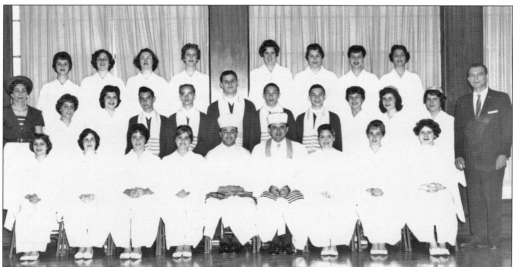

Even as bar mitzvahs returned to the Reform Temple Israel along with the more recent bat mitzvah ceremony for girls, Dayton's non-Reform synagogues adopted the Reform confirmation ceremony for high schoolers, as evidenced in this image of Beth Abraham's confirmation class of 1960. Seated in the center are Cantor Abraham Lubin (left) and Rabbi Joseph Sternstein. Beth Jacob Synagogue also began confirming teenagers. (Beth Abraham.)

Sharing the bima at Temple Israel in 1960 are Dayton's three congregational cantors, (from left) Matus Radzivilover of Beth Jacob Synagogue, Howard Greenstein of Temple Israel, and Abraham Lubin of Beth Abraham Synagogue. They played key roles in the local premiere of Ernest Bloch's *Sacred Service* with the Dayton Philharmonic Orchestra and choirs conducted by Paul Katz for Dayton's annual Jewish Music Festival. (JFGD/WSU.)

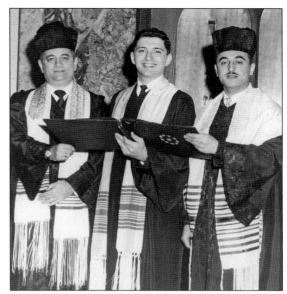

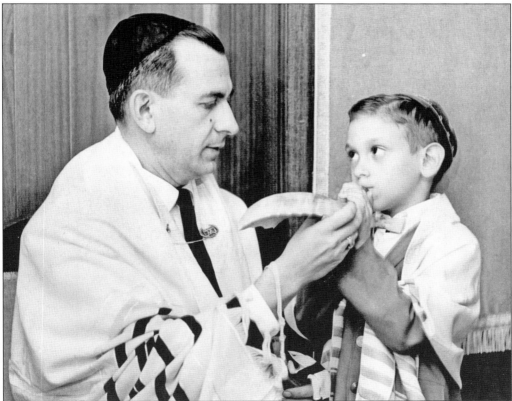

Beth Jacob Synagogue's Rabbi Samuel Fox teaches his son Hillel in 1965 how to sound the *shofar*, a ram's horn heard in synagogue over the month leading up to and during the High Holy Days. Twenty-nine years later, Rabbi Hillel Fox would follow his father as the congregation's rabbi. (DDN/WSU.)

The Orthodox minyan that Herbert Jaffe, Leo Koenigsberg, and Al Kuhr started in the early 1960s in their homes became Congregation Shomrei Emunah (Guardians of the Faith), and moved to 1706 Salem Avenue in 1976. With 35 families by the 1980s, Shomrei Emunah affiliated with the Orthodox Union and the Young Israel Orthodox movement. Principals of Hillel Academy day school often doubled as rabbis for the synagogue. (DJO.)

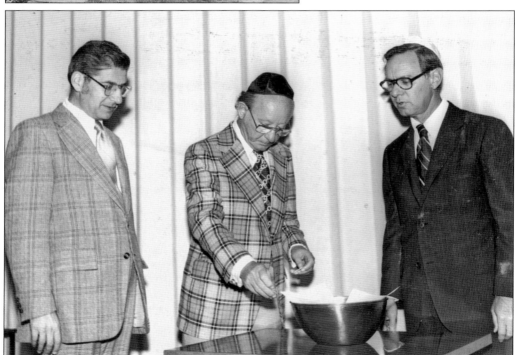

Beth Abraham Synagogue declared independence from its mortgage in 1976 at this mortgage-burning ceremony led by (from left) Rabbi Jack Riemer, Sol Friedman, and Pres. Irvin Zipperstein. A prolific author of books, essays, and prayers, Rabbi Riemer founded the National Rabbinic Network, a support system for rabbis across Judaism's movements. (Beth Abraham.)

Born in Mississippi and raised in Georgia, Rabbi P. Irving Bloom became Temple Israel's senior rabbi in 1973. Following his 1956 ordination from Hebrew Union College-Jewish Institute of Religion in Cincinnati, he entered the Air Force as a chaplain and was stationed in Germany. Jewish soldiers on leave studied Torah with him at Berchtesgaden, near Hitler's mountaintop retreat, which Rabbi Bloom called "poetic justice." (Temple Israel.)

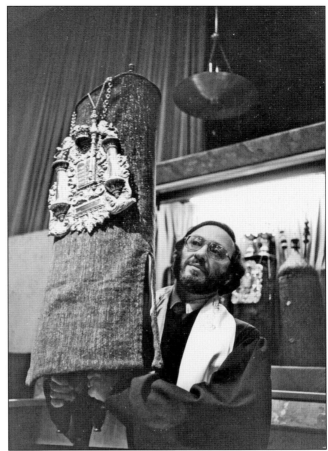

Rabbi Samuel Fox (left) swears in Beth Jacob Synagogue officers (left to right) Carol Pavlofsky, Raymond Pavlofsky, Dr. David Stine, Joe Berger, David Kress, and Pres. Hy Blum. Carol Pavlofsky was a master fundraiser and mentor to volunteers with the Jewish Federation, first as director of the United Jewish Campaign Women's Division from 1979 to 1990, and then as director of the campaign until 1997. (Beth Jacob.)

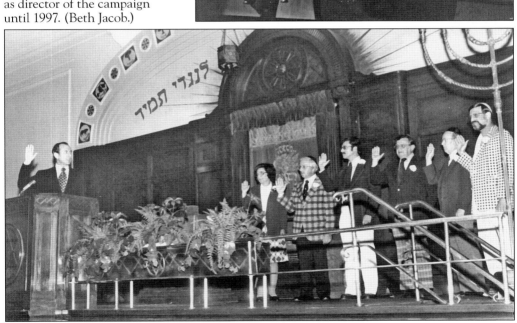

Between 1971 and 1983, the Beth Abraham Youth Chorale garnered a national reputation for its excellence. Cantor Jerome Kopmar founded and led the ensemble, comprising youths from local synagogues. Each year, he commissioned, premiered, and recorded new Jewish works with the chorale. Its tour choir performed across the United States, England, and in Israel for Menachem Begin, Moshe Dayan, and Golda Meir. (Beth Abraham.)

Beth Abraham Synagogue's Rabbi Samuel B. Press, religious school chair Barbara Miller (left), and director of youth education Rochelle Wynne pose with confirmands in 1988. A Hartford native, Rabbi Press was ordained at Jewish Theological Seminary and served as an Air Force chaplain in Alaska. From his 1978 arrival in Dayton onward, he facilitated the Conservative movement's move toward women's full equality in worship. (Beth Abraham.)

Beginning in the late 1940s, all of Dayton's Jewish congregations were located in Dayton View and the majority of Dayton's 5,500 Jews called the neighborhood home. By the 1960s and 1970s, the Jewish community began migrating primarily to the suburbs northwest of Dayton. In 1975, a year after Beth Jacob Synagogue permitted mixed seating in its sanctuary, its board decided the time was right to raise funds for a new building, which was dedicated on May 4, 1980, at 7020 North Main Street in Harrison Township. Above is the contemporary main window of fractured glass in the new sanctuary, designed by Franklin Art Glass Studios of Columbus. Below, members of the Beth Jacob board bring the congregation's Torah scrolls to the new ark. (Both, Beth Jacob.)

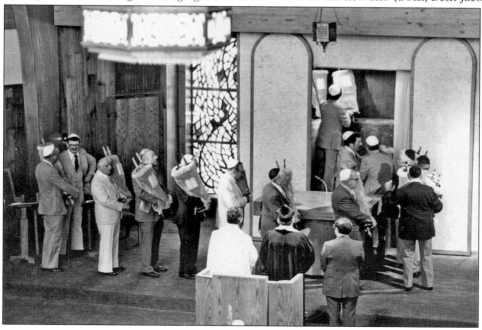

By the mid-1980s, 18 percent of the area's Jewish population lived in the suburbs south of Dayton. In 1984, thirty-five families in the south suburbs founded the Reform congregation Temple Beth Or (House of Light), led by newly ordained Rabbi Judy Chessin (above, second from right). A native of Orlando, Rabbi Chessin was ordained at Hebrew Union College-Jewish Institute of Religion in Cincinnati. From the beginning, Temple Beth Or held its services at Fairhaven Church, 5275 Marshall Road in Washington Township. The temple soon purchased and renovated the building. With Rabbi Chessin, above, is the confirmation class of 1987: (from left to right) Jerry Weckstein, Alyson Flagel, and Jenny McKenney. At left is the first couple to be married at Temple Beth Or, Karen and Kevin Bressler, in 1987. (Above, Temple Beth Or; left, Karen Bressler.)

Five

AT PLAY

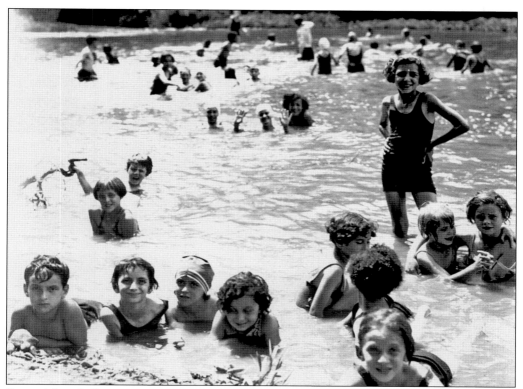

Dayton's Jewish Community Center summer campers swim at Island Park on July 26, 1934. Because of the Great Depression, the Jewish Federation was forced to cut its summer camp to serve only children "physically in need." Even so, families such as the Sanderses and Thals would sponsor picnics and swimming outings for all Jewish children. One of the campers took this photograph for the JCC camera club. (JFGD/WSU.)

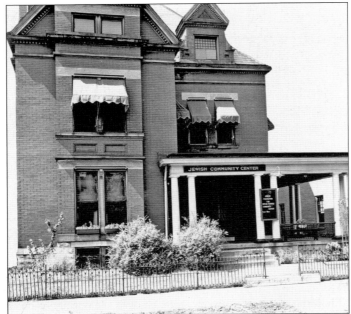

In 1922, the board of the Jewish Federation purchased a building at 59 Green Street (left), to serve as Dayton's Jewish Community Center. Led by the JCC's executive secretary, Jane Fisher, 59 Green Street became a hub of Jewish social life in the 1920s. Immigrants from eastern Europe came there for classes in citizenship training, English, and handicrafts, as well as cultural and social opportunities. Activities for children included Boy Scouting, dance and music classes, outings, and even fishing in the backyard. (JFGD/WSU.)

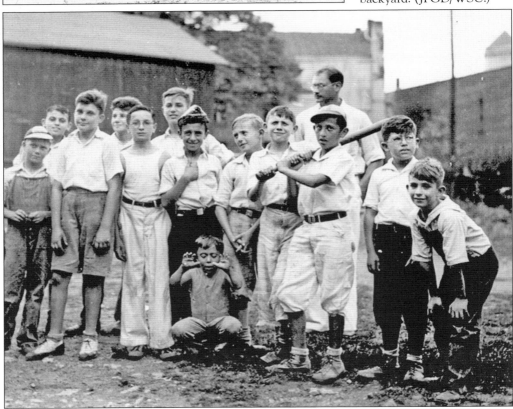

The recreational programs kept children off the streets and channeled their energy positively, as shown in this picture of "Babe Ruths" in the making in the summer of 1934. (JFGD/WSU.)

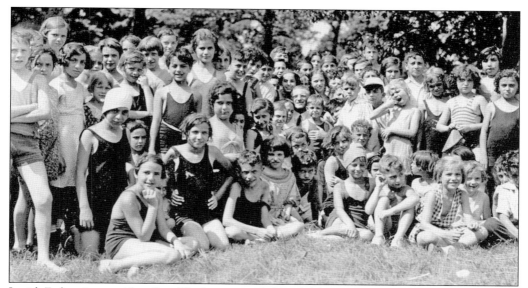

Jewish Federation president Sam Thal is surrounded by children at the JCC's picnic at Siebenthaler Bridge Camp on June 28, 1934. Thal, the owner of a jewelry store, enjoyed the outings as much as the campers; he got right in there with the children, played ball, and joined all the fun. (JFGD/WSU.)

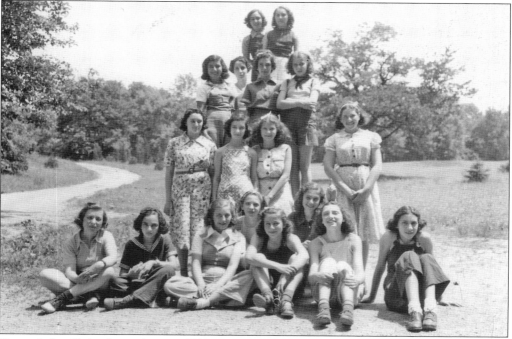

Young Judea Girls, shown here in 1938, was one of several Jewish youth programs to sprout in Dayton between the 1920s and 1950s, including the Weprin Chapter of B'nai B'rith's Aleph Zadik Aleph for boys, B'nai B'rith Girls, Alpha Sigma Chapter of Pi Tau Pi fraternity, Sigma Theta Pi and Mu Omega Tau sororities, synagogue and temple youth groups, and Boy Scout Troop 65. (Shelly Charles.)

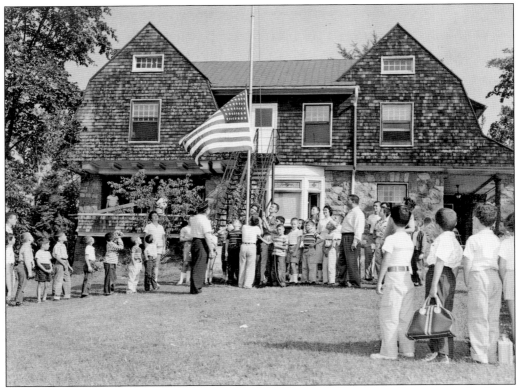

From the mid-1950s to the early 1960s, John Bryan State Park in Yellow Springs was the home of Camp Jaysee, the Jewish Community Council's summer day camp. The Jewish Federation had changed its name to the Jewish Community Council in 1944. Here, campers raise the flag for the day's activities. Camp Jaysee for preschoolers was held at the Hebrew Institute on Cornell Drive. (JFGD/WSU.)

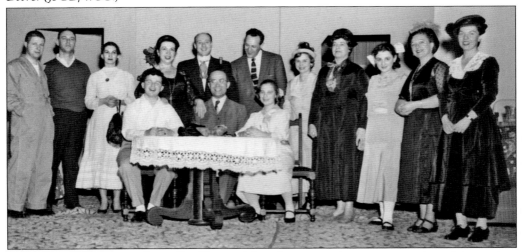

It was de rigueur for just about all of Dayton's Jewish organizations to put on plays, skits, variety shows, and musicals for fun. Here, members of Beth Abraham Synagogue present Me and Molly, a send-up of The Goldbergs. (Shelly Charles.)

Thelma Bennett and other members of Meadowbrook Country Club schmaltz it up in one of Meadowbrook's shows. Established in 1924 on Salem Pike—when country clubs excluded Jews from their membership rosters—Meadowbrook became the social center for Dayton's Jews who had "made it." Members played golf and tennis, swam, and were required to make donations to Jewish causes. (Shelly Charles.)

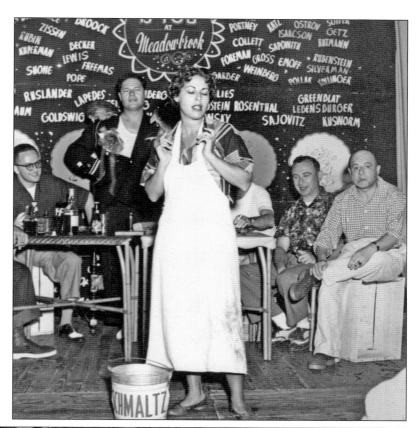

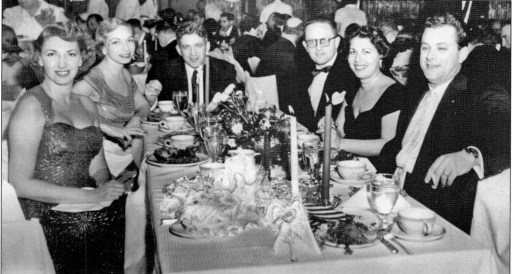

Meadowbrook members enjoyed "the best dinner in town." Shown here in the main dining room of the Meadowbrook Clubhouse are (from left) Shirley Miller, Paula and William Gans, Milton and Thelma Bennett, and Norman Miller. Under the watchful eye of club manager Ted LaVeris, the club ran like clockwork. (Jaime Miller.)

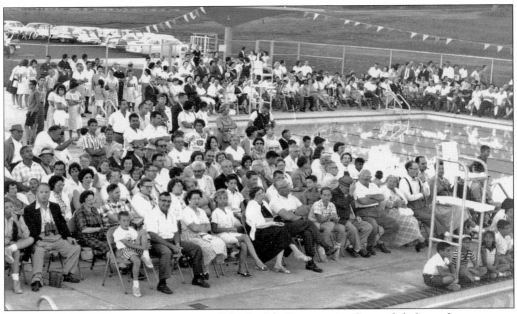

| JEWISH CENTER SNACK BAR DAYTON, OHIO Void if detached 29479 | 5 CENTS |

The Jewish Community Council dedicated an outdoor pool on its 54-acre campus in Madison Township (later merged into Trotwood) on August 6, 1961. The council purchased the site in 1956, with the outdoor pool and summer camp as its first activities there, on its way toward building a Jewish Community Center and Jewish nursing home. In observance of Shabbat, between sundown on Fridays and sundown on Saturdays, smoking, card playing, and cooking were prohibited at the pool. On Saturdays, the pool opened at 1:00 p.m., as not to interfere with participation at synagogue Shabbat services; food that did not require cooking could be secured at the snack bar on Shabbat with tickets (left) purchased in advance. The snack bar served kosher food and was run by restaurant operator and caterer Charlie Brennan. (Both, JFGD/WSU.)

Two generations of Dayton community members—Jewish and non-Jewish—learned to swim at the Jewish Center's 50-meter pool, one of the largest in the region, at 12,100 square feet. In 1962, its first full season, pool attendance was 63,718 guests and 1,043 families were members of the new Jewish Center. (JFGD/WSU.)

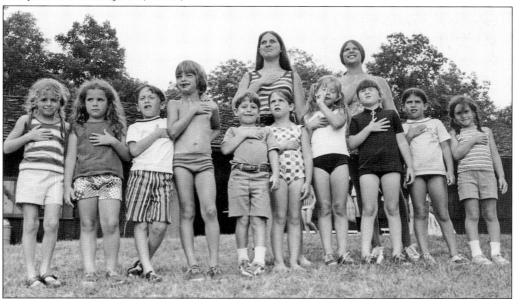

With the opening of the Jewish Center's outdoor pool in the summer of 1961 at its new campus, its summer camps moved there, too. Here, campers participate in the time-honored tradition of flagpole first thing in the morning. Camp activities included tennis instruction, modern dance, overnights, arts and crafts, softball, and, of course, swimming. (JFGD/WSU.)

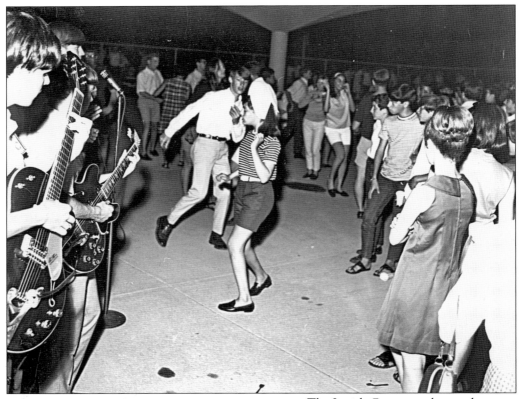

The Jewish Center pool proved an ideal setting for evening events such as this teen dance in 1967, even if most were still wallflowers. Eventually, the center had to hire a night guard to keep young adults from hopping the fence and holding their own private pool parties after hours. (JFGD/WSU.)

Robert and Audrey Margolis congratulate their daughter Merrie Lyn at her sweet 16 party, August 1965, at Meadowbrook Country Club. An American rite of passage embraced heartily in the Jewish community, the sweet 16 has faded from prominence on the social scene in recent years, possibly because of the increase in bat mitzvahs across all Jewish movements. (DDN/WSU.)

Six

AT LEARNING

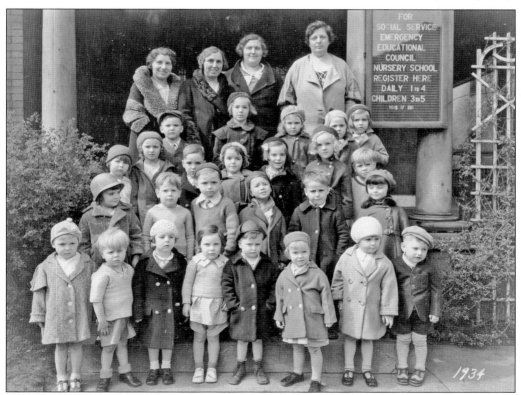

In the 1930s, Dayton's Jewish Federation ran a nursery school from its Jewish Community Center at 59 Green Street in the Oregon District. Jane Fisher (back right), the JCC's executive secretary, oversaw every aspect of the center's programming. For teenagers, the Jewish Federation offered vocational guidance and a student loan fund. (JFGD/WSU.)

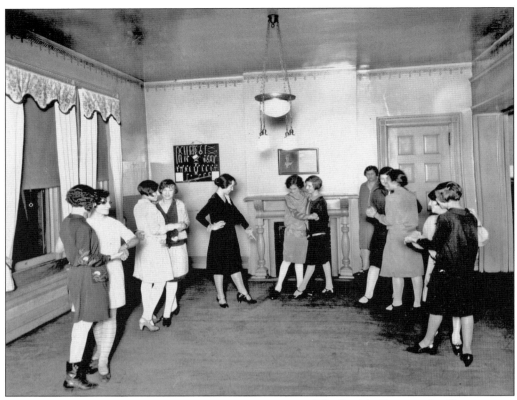

The Jewish Community Center at 59 Green Street taught Jewish immigrants American social skills, as seen in this dance class from the 1920s. For the year ending 1923, the center's executive secretary, Miriam S. Van Baalen, reported that "the spirit fostered in this community center promotes better Americanism, better Judaism and encourages education and culture." (JFGD/WSU.)

Citizenship classes such as this one in 1936 met at the Jewish Community Center to help Jewish immigrants become naturalized citizens and learn English. The chair of the Council of Jewish Women's Immigration Committee would make the first visit to newly arrived Jewish families or individuals in Dayton. She would encourage them to enroll in JCC Americanization classes and clubs. (JFGD/WSU.)

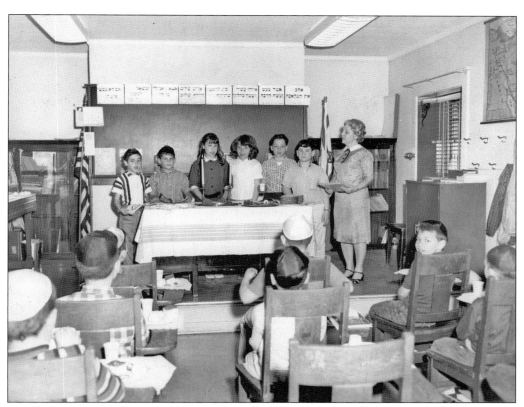

The Hebrew schools that served Dayton's synagogues first merged into one organization, Dayton United Hebrew Schools, in the fall of 1933 with approximately 250 students. By the time this photograph was taken in the 1950s, classes were held in the Dayton Hebrew Institute building at Salem Avenue and Cornell Drive in Dayton View, the same campus that was home to Beth Abraham United Synagogue. (JFGD/WSU.)

A longtime teacher with the Dayton Hebrew Institute was Miriam Fox, wife of Beth Jacob Synagogue's Rabbi Samuel Fox. Originally from Cincinnati, she was also principal of Beth Jacob's Sunday school, taught at Hillel Academy Jewish day school, and even taught Hebrew to Marianist priests with the University of Dayton in the 1970s. (JFGD/WSU.)

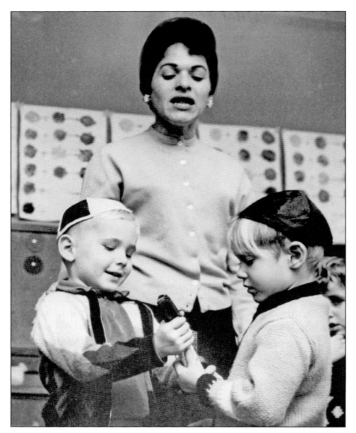

Hillel Academy teacher Gloria Brackman sings a Jewish song while students Leonard Kreitzman (right) and David Weinberger hold a miniature Torah in October 1966. Dayton's Jewish day school, Hillel Academy was established in 1962 with six children. Over its first decade, the school's location rotated among classrooms at Beth Abraham and Beth Jacob Synagogues, as well as a Dayton View church. (DDN/WSU.)

Hillel Academy fifth grader Michael Davidson studies Hebrew in October 1966. Michael would be a member of the first graduating class of Hillel Academy—eight eighth graders—in June 1970, along with Emanuel Adler, Shel Bassel, Anthony Deutsch, Joshua Fox, Jeffrey Lubow, Yosef Riemer, and William Stein. Parents themselves presented graduation certificates to their children. Enrollment at Hillel in 1970 was about 150 students. (DDN/WSU.)

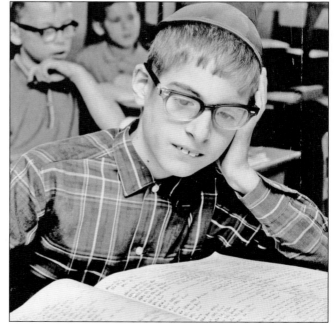

Hillel Academy moved into its own building on Woodbury Drive in Harrison Township in 1973. For parents who required Jewish day schooling for their children, Hillel meant an end to boarding them out of town or long-distance daily commutes to Cincinnati. Court-ordered desegregation of Dayton Public Schools beginning in 1976 and the declining quality of public education in the district also led to a boost in enrollment at Hillel. (DDN/WSU.)

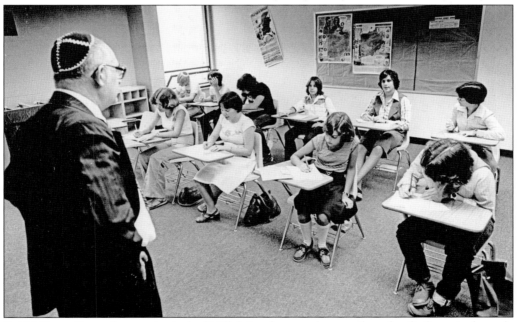

Rabbi Harry Rottenberg, principal of Hillel Academy, welcomes the school's first ninth-grade class in August 1977—then the entire high school student body—when the Jewish day school expanded to include a high school. Four years later, this class would be the first to graduate from Hillel's high school. (DDN/WSU.)

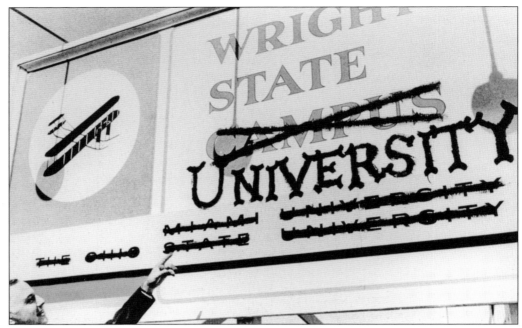

Wright State University's first president, Brage Golding, points to the main campus sign in 1967 at the time its charter officially went into effect. The university started in 1964 as the Dayton area's campus for Miami and Ohio State Universities. Golding nurtured the university's early growth to comprise four colleges and a graduate school. (WSU.)

Dr. Eric L. Friedland (left) arrived in Dayton in 1968 to serve as Sanders Professor of Judaic Studies for United Theological Seminary, the University of Dayton, Wright State University, and for a time, Antioch College. An authority on liberal Jewish liturgy, Friedland received his doctorate from Brandeis University. Here, he participates in the first National Workshop on Catholic-Jewish Relations, at Dayton's Bergamo Center in 1973. (DDN/WSU.)

Seven

SOCIAL JUSTICE

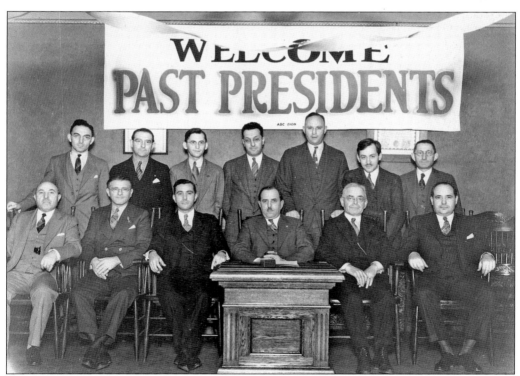

Dayton's B'nai B'rith Eshcol Lodge 55 was established in 1864, twenty-one years after the service organization's founding in New York. B'nai B'rith supported college Hillel foundations, established the Anti-Defamation League, and funded youth programs and hospitals. Shown here are past presidents of Dayton's lodge in 1931, including Sidney G. Kusworm (seated, right), chairman of B'nai B'rith International's Commission on Citizenship and Civil Affairs for 41 years. (Temple Israel.)

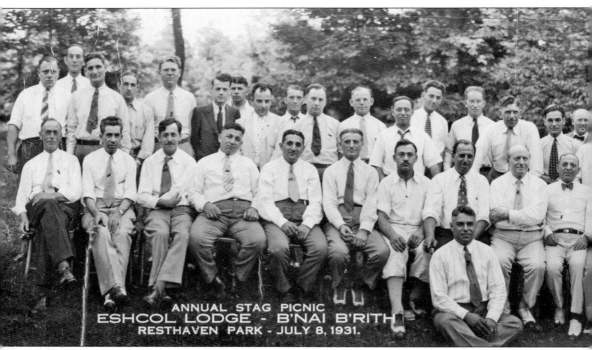

ANNUAL STAG PICNIC
ESHCOL LODGE - B'NAI B'RITH
RESTHAVEN PARK - JULY 8, 1931.

Dayton's B'nai B'rith lodge holds its "stag picnic" at Resthaven Park on July 8, 1931. In the 1920s and 1930s, the lodge's largest annual fundraisers were its winter dance and summer picnic. Approximately 5,000 people would attend the summer picnic, held at Forest Park, and later at Eagles' Park. For 25¢, men, women, and children ate their fill of sandwiches prepared by Joe Kohn,

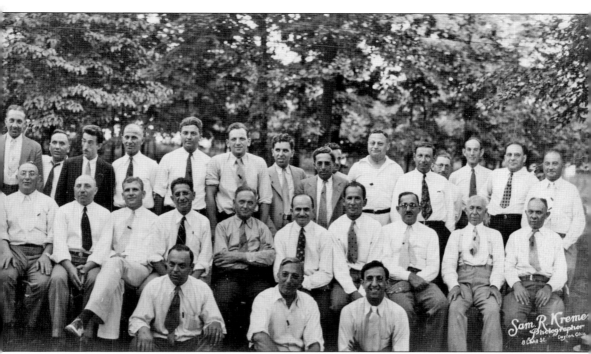

danced to a live band, watched Jewish vaudeville, played baseball, and competed in races and eating contests. At the end of the picnic, B'nai B'rith would give away a new car. In 1928, second prize was a cottage site lot at Miami Villa Summer Resort, to enjoy a "summer home along the cool and refreshing Miami River, just 20 minutes' ride from the heart of Dayton." (JFGD.)

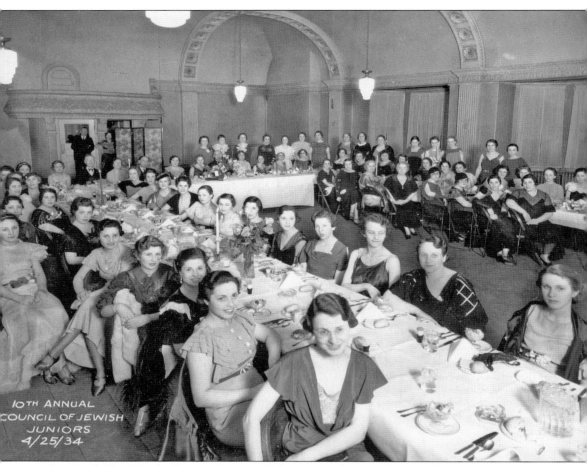

10TH ANNUAL
COUNCIL OF JEWISH
JUNIORS
4/25/34

On April 25, 1934, the Dayton Section of the National Council of Jewish Juniors celebrated its 10th anniversary. The council's aim was "to unite the young Jewish women of Dayton into one harmonious group and train the girls for leadership." The Jewish Juniors raised funds for scholarships; supported the Cuban Sheltering Home, which provided foreign girls with housing in America; contributed to the Community Chest; and helped the JCC on Green Street with its summer play program. Jewish women's organizations found in Dayton in the early 20th century included Hadassah (established locally in 1925), Junior Hadassah (1930), the Jewish Federation Ladies Auxiliary, Congregation B'nai Yeshurun's Ladies' Hebrew Relief Society, and the Babette Schwarz Sewing Guild. Among the other local Jewish organizations in those days were the Dayton Zionist District (1910), a Hebrew free loan society, Young Men's Hebrew Association, Independent Order of the Sons of Benjamin, Jewish Agriculturalists' Aid Society, Jewish Chautauqua Society, B'rith Achim Lodge, Ahavas Rehim Lodge, and Jewish National Workmen's Alliance. (JFGD/WSU.)

Because of the rise of Nazism in Europe and shrinking allocations from Dayton's Community Chest, the Jewish Federation established the United Jewish Council in 1934 as a separate entity to raise funds for local, national, and international Jewish causes. The council held its first campaign event on September 5, 1934, at the Biltmore Hotel. *Dayton Daily News* publisher and former Ohio governor James M. Cox was a key speaker. The 1934 campaign raised $25,214 from 937 contributors. The council helped the federation provide hundreds of Dayton's Jews with food, rent, coal, clothing, hospitalization, insurance, and recreation. The federation also offered domestic relations counseling, free loans, legal aid, foster care, services for delinquents, an adoption agency, student loans, and vocational and citizenship classes. The council's largest overseas allocations from that first campaign were $5,000 for the Joint Distribution Committee and $2,500 to United Palestine Appeal to aid Europe's Jews. In 1939, the federation and the council began accepting each month a refugee family and refugee child, who also received medical and dental care, furnishings, food, light, and rent. (JFGD/WSU.)

Donations to Dayton's War Chest were the Jewish community's highest priority during World War II. Dayton's Jewish Army Navy Committee, USO–Jewish Welfare Board, synagogues and Hadassah hosted local dances (above), entertainment, and holiday meals for hundreds of Jews in the military and their spouses, with funds from the War Chest. Dayton's B'nai B'rith shipped care packages to area Jewish soldiers stationed overseas. Young Jewish Women established the War Activities Group under the auspices of the Jewish Community Council. The council was formed through the 1944 merger of the Jewish Federation, Jewish Council for Community Activities, United Jewish Council, and Jewish Army Navy Committee. The photograph below—of Navy Lt. (jg) Lee Charles kissing his wife, Shelly Charles, on V-J Day—made the cover of the *Dayton Daily News*. (Above, JFGD/WSU; below, Shelly Charles.)

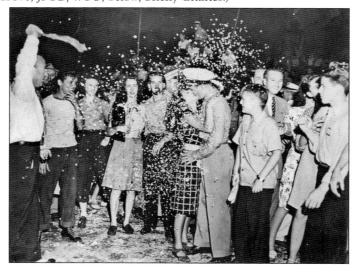

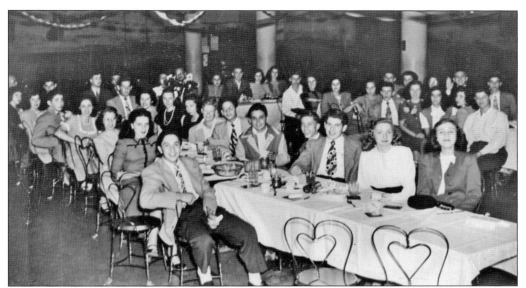

Even with tight immigration restrictions in the United States, between 1938 and 1941, Dayton's Jewish Federation resettled 70 Jews who had escaped the Holocaust. Through the 1940s, Dayton's United Jewish Campaign sent at least 70 percent of its dollars to United Jewish Appeal to provide relief and rescue for the few Jews able to flee the Nazis. After the war, President Truman loosened restrictions on immigration for those displaced by the Nazis; 28,000 displaced Jews then immigrated to the United States. Above, the United Jewish Campaign Youth Division meets in 1945. Seated at the table is Walter Ohlmann (third from right), whose family fled Nazi Germany in 1939. Below, Jewish Community Council volunteers hold an SOS drive in 1948, sending 52 cartons of layette items and 10,000 pounds of canned food to Jewish displaced persons in Europe. (Both, JFGD/WSU.)

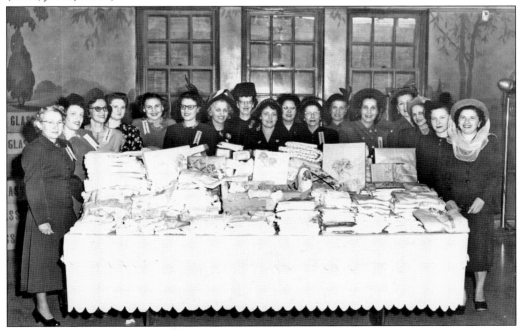

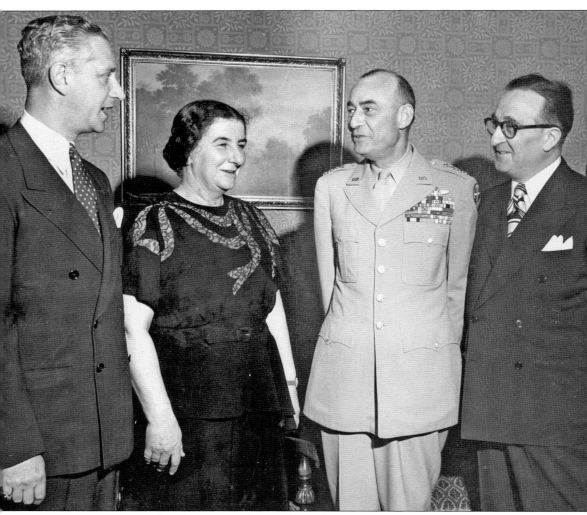

On June 8, 1948, at the Biltmore Hotel, United Jewish Campaign chair A.B. Saeks (right) presented Golda Meyerson (later Golda Meir)—the only woman in Israel's provisional government—with a $300,000 check for the weeks-old Jewish state, fighting for its life against five Arab armies. Dayton's Jewish Community Council borrowed the funds from the Winters and Third National Banks based on 1948 pledges to United Jewish Appeal. Meyerson, who would become Israel's prime minister two decades later, raced across America to raise $100 million in cash for Israel by August 1 for the Jewish state's immediate development, and to provide relief, aid, and absorption for Europe's displaced Jews. The national campaign raised $250 million. With Meyerson and Saeks are council president Charles Goldswig (left) and US Air Force general Joseph McNarney. By October 1948, 60,000 Jewish DPs had entered Israel at a rate of 10,000 per month. To help meet these relief and absorption needs, Dayton's United Jewish Campaign jumped from $58,000 in 1941 to $641,627 in 1948. By 1949, the council had resettled 19 Jewish DPs in Dayton. (JFGD/WSU.)

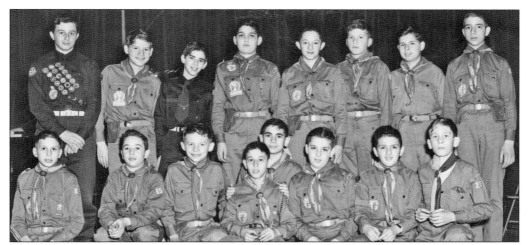

As far back as the 1920s, Dayton's Jewish community sponsored a Boy Scout troop. Shown here are members of Boy Scout Troop 65 and Cub Pack 65 in 1954. Their Scoutmaster was Charles Abramovitz. The troop and pack were sponsored at that time by the Jewish Community Council. Dayton's B'nai B'rith lodge and Temple Israel also sponsored the Jewish Scouts over the years. (JFGD/WSU.)

Jewish War Veterans Post 587 and its auxiliary dedicate the waiting room of the domiciliary clinic at Dayton's Veterans Administration hospital in 1955. The auxiliary funded the waiting room's renovation. At the left are JWV Post 587 commander Irving Neiman and JWV Auxiliary hospital chair Pearl Rittner. (JWV Post 587.)

Holocaust survivor Laszlo Balazs (right), the first Hungarian Jewish refugee resettled in Dayton in 1956, meets with Jewish Family Service director Bertram Silverman (left) and translator I.M. Marks. Dayton's Jewish Community Council resettled five Hungarian Jewish families who fled the Soviet invasion following the Hungarian Revolution. Jewish Family Service, a division of the council, resettled two Egyptian Jews who fled persecution by Gamal Abdel Nasser's regime in 1959. (JFGD/WSU.)

In 1954, a group that called itself Mateh Yisroel (Staff of Israel) dedicated Dayton's Jewish Home for the Aged, a brick dwelling at 1001 Grand Avenue. The backbone of the facility was its guild of volunteers, shown on the steps of the home. It formally became a division of the Jewish Community Council in 1964 and continued to operate until 1971. (Renate Frydman.)

Si Burick (center) presides over the transfer of the Jewish Community Council's presidency from Ted Goldenberg (seated) to Harry Weprin in 1964. An active member of the council and a sought-after master of ceremonies, Burick was a sports editor and columnist with the *Dayton Daily News* for 58 years. He would later be inducted into the Writers Section of the Baseball Hall of Fame. (JFGD/WSU.)

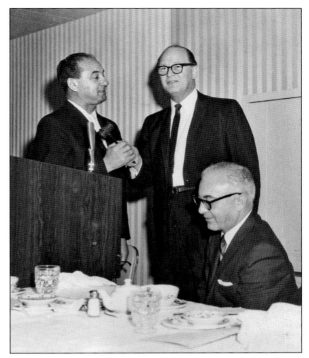

At this 1966 United Jewish Campaign Leading Ladies luncheon for the young matrons division, those present increased their giving by 29 percent. The annual luncheon featured a cruise ship theme with an "exotic menu." The young women also held their own annual telethon to solicit gifts. (JFGD/WSU.)

Dayton's Israel Emergency Campaign chair Louis Goldman (left) meets with victorious IDF chief of staff Yitzhak Rabin in Israel after the June 1967 Six-Day War. Dayton's emergency campaign raised $1.1 million, the highest per capita among Jewish communities across the United States. Goldman was a national chair of United Jewish Appeal, and traveled across the United States to help raise $322 million for the emergency campaign. (JFGD/WSU.)

Seven high school juniors with the Dayton Hebrew Institute received scholarships from the Jewish Community Council's Bureau of Jewish Education to tour Israel in the summer of 1970: (from left) Susan Krauss, Julia Davidson, Sara Fox, Sue Perlmutter, Bryna Perlmutter, Helaine Ross, and Cheryl Lubow, shown with BJE director Rabbi Saul Spiro. The council had established the BJE in 1963 to set community standards for Jewish education. (JFGD/WSU.)

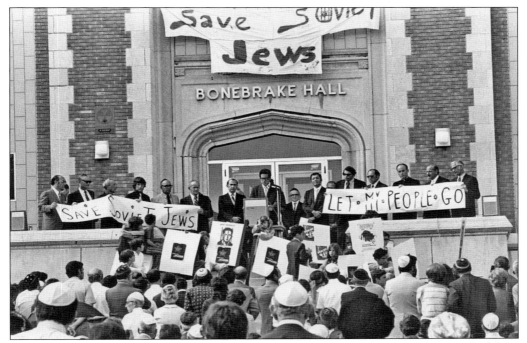

On the afternoon of Yom Kippur, September 29, 1971, approximately 1,000 Jews marched from their synagogues to demonstrate on behalf of Soviet Jewry, at a rally on the United Theological Seminary campus. Rabbis urged the Soviet government to stop discriminating against Jews and to allow Soviet Jewish immigration to Israel. Over the 1970s, Dayton's Jewish Family Service was able to resettle approximately 50 families from the Soviet Union. (JFGD/WSU.)

On October 8, 1973, two days after the start of the Yom Kippur War, Dayton's Jews rallied at Temple Israel to support an emergency campaign for Israel. Through the Jewish Community Council, the campaign raised $2 million. "The mobilization was just unbelievable," recalled Peter Wells, then assistant to the executive director of the council. "Social Security pensioners were coming in with their checks." (JFGD/WSU.)

Phyllis and Samuel Heider visit the Western Wall on a 1974 Jewish Community Council mission to Israel. Married in a German DP camp in 1946, Phyllis survived Bergen-Belsen and Samuel survived five concentration camps including Auschwitz and Dachau. In 1949, they and their son arrived in Dayton with help from the Hebrew Immigrant Aid Society and the council. He is a tireless speaker about the Holocaust. (Samuel Heider.)

A teacher with Dayton Public Schools, Ellen Faust became a civil rights activist with the League of Women Voters and then with the Council of Jewish Women, Dayton Urban League, and Jewish Community Relations Council. From 1983 to 1985, she served as president of Dayton's Urban League. The JCRC, chaired by Dr. Louis Ryterband, lobbied for the 1964 Civil Rights Act. (DDN/WSU.)

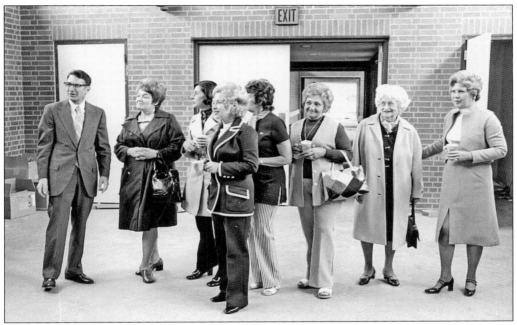

Covenant House director Bertram Brant gives a tour of the new facility to members of its volunteer guild. The Jewish nursing home, which replaced the Jewish Home for the Aged on Grand Avenue, opened at the Jewish Community Council's campus in Trotwood in 1973. A decade later, Covenant Manor—a 50-unit housing complex for low-income seniors and those with disabilities—would open on the campus. (JFGD/WSU.)

The Jewish Community Council opened a full-service Jewish community complex at its Trotwood campus on September 10, 1978. The complex was named for lead donor Jesse Philips, shown here at the dedication. It was home to the Jewish Community Center, Jewish Family Service, and the council. The founder of Philips Industries, Philips also chaired the University of Dayton's board. (JFGD/WSU.)

The dedication of the Jesse Philips Building in 1978 also marked a significant transition for the Jewish Community Council. Its executive vice president, Robert Fitterman (left), who had led the council since 1947, retired shortly after. With his retirement, Peter Wells (right) became the council's executive director. They are shown with executive assistant Sylvia Siegle, who retired the following year, after 19 years of service. (JFGD/WSU.)

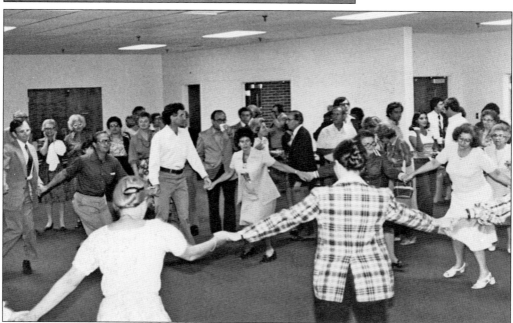

The Jesse Philips Building became a place where Jews across religious movements could come together and celebrate Jewish culture and education—from preschoolers in the early childhood program to senior citizens, from teenagers and young adults to couples. Here, community members dance the hora (circle dance) at an Israel Night program. (JFGD/WSU.)

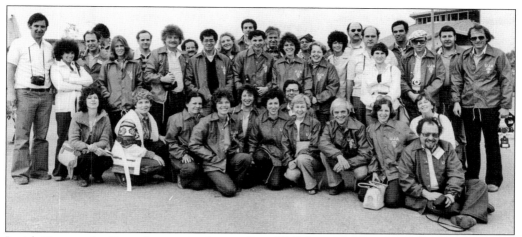

Jewish Community Council executive director Peter Wells knew the key to inspire emerging leaders was to take them to Israel. In March 1979, Wells (seated, right), led a contingent on a national United Jewish Appeal young leadership mission to Israel. Here, they visit an Israel Defense Forces air base. Later that year, the council would change its name to the Jewish Federation of Greater Dayton. (JFGD/WSU.)

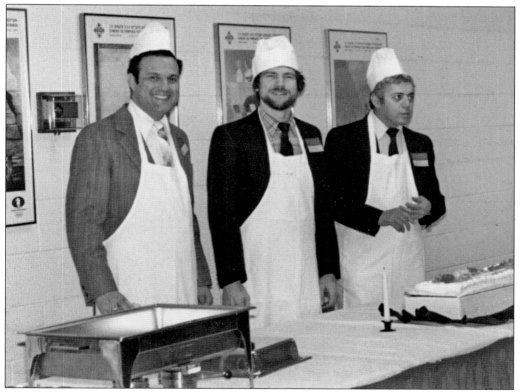

Ready to serve the community for decades were the executive directors of the Jewish Federation's main agencies: (from left) Rabbi Sheldon Switkin with Jewish Family Service; Dr. Arthur Cohn, first with JFS and then Covenant House nursing care facility; and Melvin Caplan with the Jewish Community Center. (JFGD/WSU.)

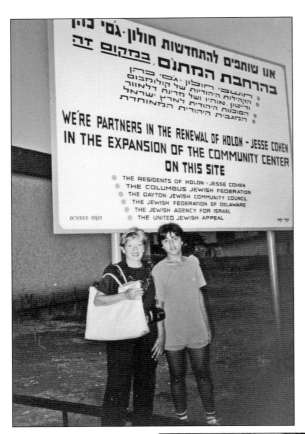

In 1985, Barbara Katz and a youth in Holon's Jesse Cohen neighborhood in Israel tour a community center expansion, partially funded by Dayton's Jewish Federation. In 1983, the federation joined Project Renewal to help the impoverished neighborhood. Daytonian Beth Zuriel oversaw the project in Israel. In 1987, Jesse Cohen opened the center's Si and Rae Burick Sports Wing, and in 1998 Holon became a Dayton sister city. (Bernard Rabinowitz.)

When communism collapsed in the Soviet Union, United Jewish Appeal initially launched Passage to Freedom to resettle approximately 50,000 Jews from the Soviet Union to Israel and the United States. Dayton's campaign raised $180,000. In August 1989, the campaign's first Soviet Jewish family arrived in Dayton (right)— Natalie, Lev, and Roman Koyrakh, shown with volunteers (from left) Dr. Mel Lipton, Irvin Moscowitz, Alex Sobolev, and Elaine Bettman. (JFGD/WSU.)

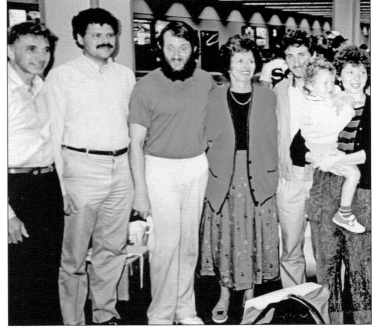

Eight

SOME PERSONALITIES

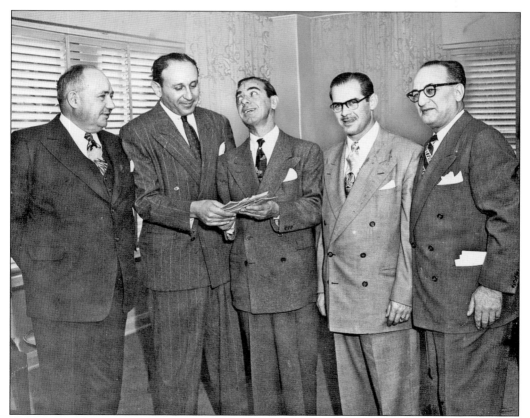

Entertainer Eddie Cantor (center) kibitzes with contribution checks at a United Jewish Campaign luncheon in 1950. With Cantor are (from left) Sidney G. Kusworm, toastmaster of the luncheon; Clarence Lapedes, chairman of the pledge redemption drive; Louis Matusoff, Jewish Community Council president; and Ben Shaman, chairman for the Oneg Shabbat. (JFGD/WSU.)

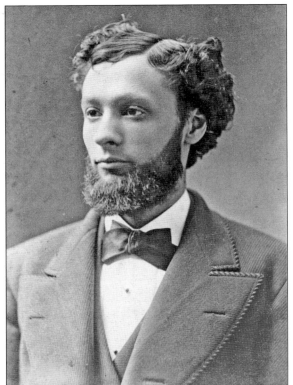

Gustave Lindeman, manager of the Dayton City Club, on the southwest corner of First and Main Streets (below), called Dayton home from 1895 until his death in 1927. In 1883, when Lindeman catered for the Allemania German-Jewish club in Cincinnati, Rabbi Isaac Mayer Wise hired him to prepare a banquet celebrating Hebrew Union College's first rabbinic ordinations and the Union of American Hebrew Congregations' 10th anniversary—Wise founded both. Wise hoped to unite American synagogues and rabbis within Reform Judaism. Lindeman served a *treyf* (unkosher) menu, albeit without pork. No one knows if Wise or his committee approved the menu, or if Lindeman acted on his own. German Reform Jews tended to eat treyf, except for pork. But as a result, outraged traditionalists established Orthodox and then Conservative Judaism. (Left, Ellen Notbohm; below, DML.)

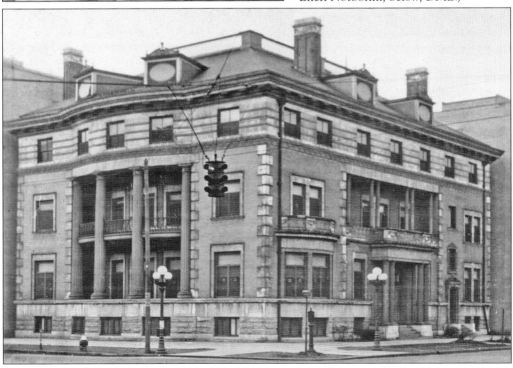

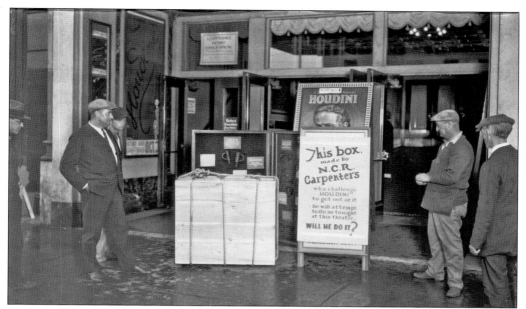

One way Harry Houdini promoted his shows on the road was to challenge prominent local manufacturers to construct containers from which he could not escape. Before his October 1, 1925, performance at the Victory Theatre, NCR carpenters crafted a box for that evening's show. Artists who took the stage at the Victory included Sarah Bernhardt, Sophie Tucker, Al Jolson, Fanny Brice, and the Marx Brothers. (Victoria Theatre Association/WSU.)

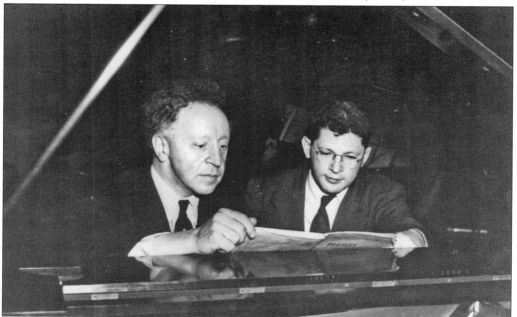

Dayton Philharmonic Orchestra founder and music director Paul Katz (right) reviews a score with pianist Arthur Rubinstein in the 1930s. A virtuoso violinist, Katz established the orchestra in 1933 and led it for 42 years. Katz also served as Temple Israel's music director for 40 years, shaping its choir and performing Kol Nidre on the eve of Yom Kippur. (DDN/WSU.)

Granddaughters of Dayton City Club manager Gustave Lindeman, sisters Josephine (left) and Hermene Schwarz founded the Schwarz School of Dance in 1927 and the Experimental Group for Young Dancers in 1937—later renamed the Dayton Ballet—the second-oldest ballet company in the United States. The sisters broke down societal divisions through dance over more than four decades, presenting integrated performances beginning in the 1940s. (DDN/WSU.)

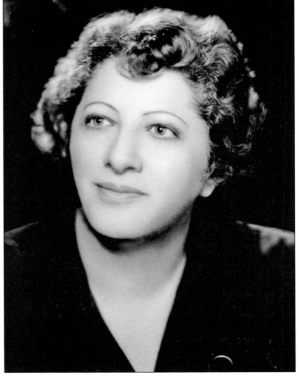

Impresario, master fundraiser, and publicist Miriam Rosenthal managed the Dayton Philharmonic Orchestra from 1935 until her death in 1965. She was the United Jewish Council's first executive secretary when it was established in 1934, and raised funds for Memorial Hall, the University of Dayton, Wright State University, Beth Abraham Synagogue, the Air Force Museum, and Kettering, Good Samaritan, St. Elizabeth's, and Miami Valley hospitals. (DDN/WSU.)

One of the first Jews to live in Oakwood was Max Kohnop, Sunday editor of the *Dayton Daily News* from 1939 to 1964. He and his wife, Minnie, moved to Monteray Avenue in 1927. From 1934 until 1976, Kohnop was president of the Oakwood Library board. He was a president of Temple Israel and chaired its cemetery, president of the B'nai B'rith lodge, and editor the Jewish Federation's newsletter. (DDN/WSU.)

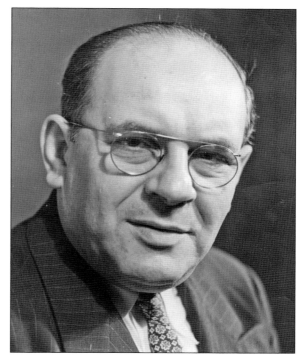

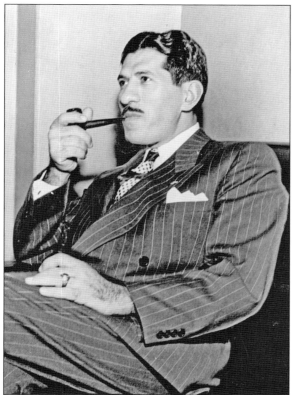

Born and raised in Dayton, economist Robert R. Nathan chaired the US War Production Board Planning Committee beginning in 1942 at the age of 33. According to the *New York Times*, "he helped lead the nation's industrial mobilization in World War II." After the war, Nathan's economic consulting firm advised and conducted studies for clients such as foreign governments— including the state of Israel—and US presidents. (DDN/WSU.)

The *Dayton Journal* assigned reporter Maxwell Nathan to the first meeting of Dayton's pro-Nazi German-American Bund on March 17, 1938. The bund would only allow Nathan, a Jew, to cover the meeting for the *Journal*, with no explanation given. Nathan reported that G. Wilhelm Kunze, a national bund leader, launched into an anti-Semitic attack. "That was the last I ever heard of the bund in Dayton," Nathan recalled years later. (DDN/WSU.)

Inventor Max Isaacson arrived at Patterson Field in 1926 to become its chief patent attorney. After the Army prohibited civilians from serving as department heads, Isaacson founded Globe Motors in 1940. He and his team of inventors designed and produced miniature practical motors for missile programs and the aircraft industry. (Joan Isaacson.)

Attempts to start a Jewish newspaper in Dayton did not stick until Milton Pinsky, publisher of the *Ohio Jewish Chronicle* in Columbus, added a Dayton edition in 1959. Anne M. Hammerman became its editor and in 1962 also began publishing the *Dayton Jewish Chronicle*. In her weekly column, Hammered Out, she was a staunch supporter of Hillel Academy day school. Hammerman sold the paper in 1983. (DDN/WSU.)

From 1947 to 1987, George Rudin's Tropics—a Polynesian-themed nightclub at 1721 North Main Street—was one of the region's hottest nightspots. The 900-seat dinner and dancing venue was known for its steaks, barbecue and Polynesian menus, top entertainers, and in the 1960s, go-go dancers. Rudin's biggest draw was drummer Gene Krupa. Actress Jayne Mansfield also performed her nightclub act there. (Natalie Cohn.)

Harris S. Abrahams (center) congratulates Joe and Elaine Bettman on receiving the Jewish Community Council's 1968 young leadership awards, the first time a husband and wife won these awards in the same year in any Jewish community in the United States and Canada. The Bettmans would play key roles in the resettlement of Soviet Jews to Dayton. Abrahams oversaw the development and construction of Dayton's Jewish Community Complex. (JFGD/WSU.)

Brothers Al (left) and Lou Levin—members of the family that owned 17 movie theaters in the Dayton area including the Kon Tiki and the Dixie Drive-In—flank Doris Day. Their older brother Sam brought the family into the theater business. Sam even wrote the script for the 1964 movie *The Girls on the Beach,* featuring Lesley Gore, the Beach Boys, and the Crickets. (Levin Family Foundation.)

Born in Frankfurt, Walter Ohlmann and his family fled Nazi Germany three months after Kristallnacht, when Walter was 10 years old. They arrived in Dayton in 1941. After Walter's Army service in the Korean War and work as a sales representative for WLWD, he would become the head of Dayton's most successful advertising agency and spearheaded numerous efforts to improve the quality of life for Daytonians. (Ohlmann Group.)

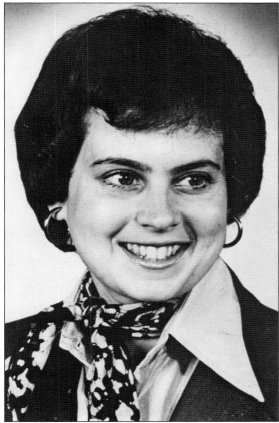

With a career that started in television—including working with Phil Donahue during his years in Dayton—Meredith Moss Levinson began writing her *Dayton Daily News* fashion column, Window Shopping, in 1976. Over decades as a columnist for the paper, Meredith has covered children's issues, philanthropy, religion, health and wellness, and the arts in a style that evokes sitting down over coffee with a dear friend. (DDN/WSU.)

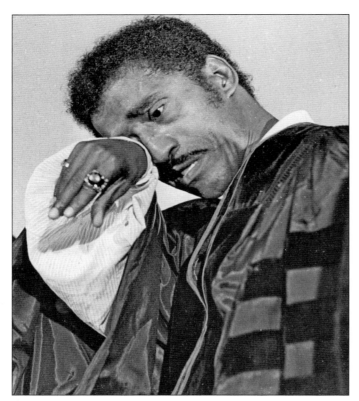

A visibly moved Sammy Davis Jr. receives an honorary degree in fine arts from Wilberforce University—the nation's oldest private, historically black university—on June 2, 1971. Nearly a year later, on May 13, 1972, Davis would return to the area and perform a concert at the University of Dayton Arena to benefit Hillel Academy Jewish day school, then facing a severe financial crisis. (DDN/WSU.)

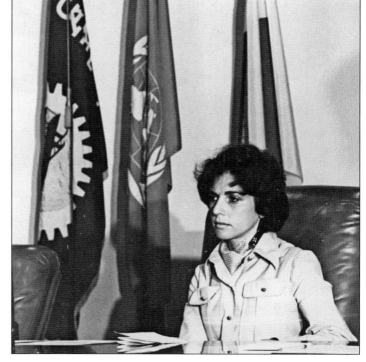

Although Gail Levin was not the first Jew on Dayton's city commission—Jacob Weinreich was president of the Dayton City Council in 1884—she was the commission's first woman. The daughter of Sis and Rabbi Selwyn Ruslander, Levin was appointed to the city commission in 1973. In 1974, she announced she would not run for reelection the following year. Levin had also served as president of Dayton's League of Women Voters. (DDN/WSU.)

In 1980, *Fortune* magazine named Richard J. Jacob, founder and chairman of Dayco, one of America's 10 toughest bosses. Jacob had built Dayco into one of the largest rubber product companies in the world. Jacob did have a soft spot for the community. He and his brother Robert founded the Hundred Club of Dayton, which provides financial support for families of police officers and firefighters in times of need. (DDN/WSU.)

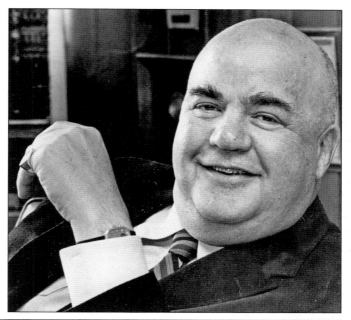

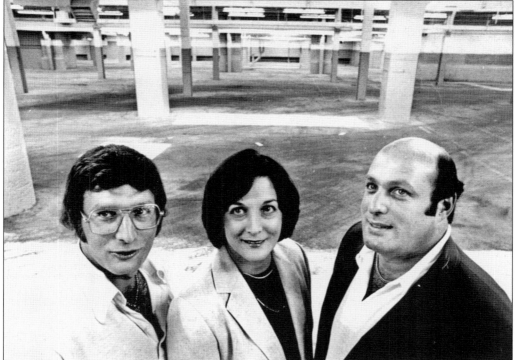

Siblings (from left) Bruce Mendelson, Marlene Pinsky, and Sandy Mendelson visit 340 East First Street, one of the old Delco Products buildings they purchased in 1981 from Virginia Kettering. There, they would transform Mendelson's Electronics—which their father, Harry Mendelson, started on Linden Avenue in 1960—into Mendelson's Liquidation Outlet, "The First Place To Look For Every Last Thing," now owned and operated by Sandy Mendelson. (DDN/WSU.)

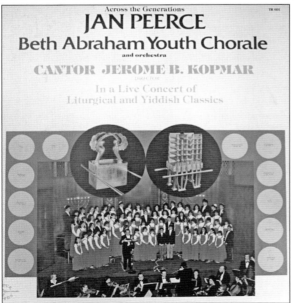

Operatic tenor Jan Peerce (above, left) performed the final concert of his career at Beth Abraham Synagogue on May 2, 1982, with the Beth Abraham Youth Chorale, conducted by its director, Beth Abraham Synagogue cantor Jerome B. Kopmar (above). They are shown here after the concert, with their wives, Alice Peerce (left) and Goldye Kopmar. "These children are not your average kids singing 'Yankee Doodle,'" Peerce said of the chorale at the end of the concert. "They are professionals." Later that month, Peerce suffered a stroke. After a prolonged illness, he died on December 15, 1984, at the age of 80. Tambur Records released the recording of the live concert (left) in 1983. (Both, Cantor Jerome B. Kopmar.)

Theodore Levitt's family arrived in Dayton from Vollmerz, Germany, in 1935. While at Parker Cooperative High School, he was a copy boy for the *Dayton Morning Journal*. After his army service in World War II, he attended Antioch College, earned his doctorate in economics from the Ohio State University, and became a noted economist at Harvard Business School and editor of the *Harvard Business Review*, popularizing the term *globalization*. (DDN/WSU.)

Paul Flacks served as national executive vice president of the Zionist Organization of America from 1980 until his retirement in 1993, and held a seat on the Conference of Presidents of Major American Jewish Organizations. Flacks was one of the founding members of the Dayton Christian-Jewish Dialogue. With Dr. Louis Ryterband, he cochaired the first National Workshop on Catholic-Jewish Relations, held in Dayton in 1973. (JFGD/WSU.)

Stuart Rose (center), chairman and chief executive officer of Audio/Video Affiliates, attends the listing ceremony for the company at the New York Stock Exchange in 1986. Rose later oversaw the transition of his company from REX retail appliance stores to investments in renewable fuels. A rare book collector of note, Rose and his family foundation support numerous causes in the general and Jewish communities. (Stuart Rose.)

Over the years, Nobel laureate Elie Wiesel (right) presented several talks in Dayton. Here, the Holocaust survivor, author, and professor is shown when he spoke at Beth Jacob Synagogue in 1987, with Dr. Herman Abromowitz, the congregation's president. The Nobel Peace Prize Committee called Wiesel a "messenger to mankind." (Beth Jacob.)

Neal Gittleman became the Dayton Philharmonic Orchestra's fourth music director in 1995, establishing a relaxed, conversational rapport with his audiences. His nationally recognized Classical Connections series offers behind-the-scenes looks at important works. In 1998, he conducted the world premiere of *Like Streams in the Desert* by Meira Warshauer at Memorial Hall to celebrate the 50th anniversary of Israel's establishment. The Jewish Federation of Greater Dayton commissioned the composition. (WSU/DPO.)

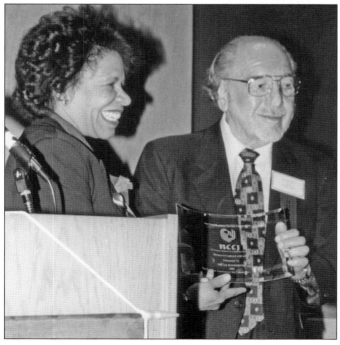

Oscar Boonshoft receives a National Conference for Community and Justice award in 2000 from Franciscan Health System's Debra P. Moore. A mechanical engineer who worked at Wright-Patterson Air Force Base from 1939 until 1970, Boonshoft successfully traded commodity futures contracts and became one of Dayton's most generous philanthropists, providing significant gifts to Jewish, scientific, and medical endeavors. Among the founders of Dayton's NCCJ chapter in 1978 was Milton Marks. (DJO.)

In a behind-the-scenes way, Joan Knoll has helped mediate challenges between Dayton's Jewish and general communities for decades. The former chair of Dayton's National Council of Jewish Women was an early activist for civil rights. She played key roles as chair of the Montgomery County Planning Commission and the Jewish Community Relations Council, and as a member of the Dayton Sister City Committee and Dayton Council of World Affairs. (DJO.)

A native of Queens, New York, Steve Bernstein opened Bernstein's Fine Catering and the Uptown Deli on North Main Street in 1988, where he sold kosher groceries when such items were difficult to find in the Dayton area. The catering operation he founded still handles the lion's share of kosher catering in the Miami Valley, preparing meals in Jewish community kosher kitchens. (DJO.)

Nine

END OF A CENTURY

Hillel Academy sixth graders Blayne Goldwasser (left), Natalie Carne, and Stephen Arnovitz decorate one of the Jewish day school's library windows in 1999 with Israeli flags and the national emblem of the Jewish state. Because of declining enrollment and budgetary constraints, Hillel discontinued its high school grades in 1999 and 2000. (DJO.)

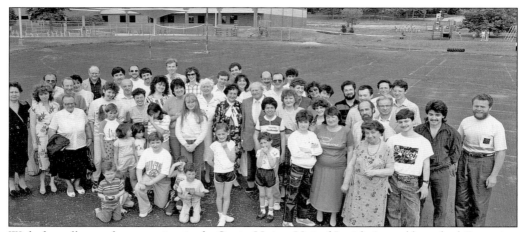

With the collapse of communism in the Soviet Union, United Jewish Appeal launched Operation Exodus in 1990, which raised $900 million and brought nearly 1 million Jews to Israel and 150,000 to the United States. Operation Exodus became the largest emergency fundraising event in Jewish history. For its part, Dayton's Jewish Federation raised close to $2 million and resettled nearly 200 Jews from the Soviet Union by 1993. Shown above are Soviet Jewish émigrés to Dayton in 1990. The federation's Jewish Family Service and volunteers collected furniture, set up apartments, found jobs, provided transportation, and helped newcomers become acquainted with Judaism. Below, US district judge Walter H. Rice congratulates Sergey Gurevich as Sofiya Gurevich looks on following their naturalization ceremony with 51 other new American citizens, held at the Jesse Philips Building, October 17, 1996. (Above, JFGD/WSU; below, DJO.)

Toward the conclusion of every bar and bat mitzvah ceremony at Temple Beth Or, Rabbi Judy Chessin (at right in the image at right) opens the Torah ark and offers a personal blessing to the student, out of earshot of the congregation. Here, she blesses bat mitzvah Rachel Haug in 1992. Another long-standing tradition at the temple has been to invite four-legged guests for special occasions, whether it involves livestock visiting the sanctuary at High Holy Days children's services or bringing pets for the blessing of the animals (below), in connection with the Torah portion about Noah. (Both, Temple Beth Or.)

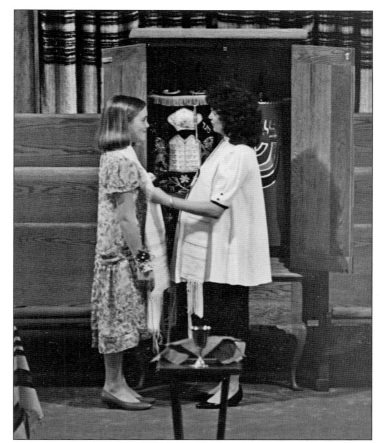

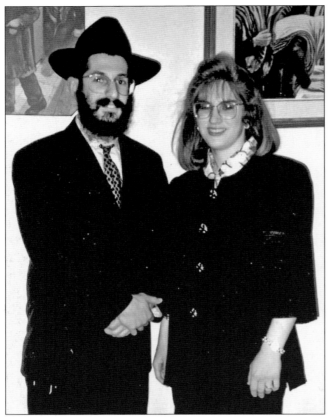

Rabbi Nochum Mangel and Devorah Leah Mangel arrived in Dayton as *shluchim* (emissaries) of the Chabad-Lubavitch movement in the summer of 1993. At first, they ran the Chabad Center of Dayton from their apartment in Kettering. Through programming and worship services, the Chasidic Jewish outreach and educational organization aims to help "every Jew, regardless of background, affiliation or personal level of observance, to increase their level of Jewish knowledge, enthusiasm, and commitment." Below, Chabad celebrates the dedication of a new Torah scroll in June 2000, carried by donor Dr. David Novick in front of the Chabad Jewish Enrichment and Learning Center, a storefront at the Washington Square shopping center, next to the JCC South/Jewish Federation office in Washington Township. (Both, Chabad.)

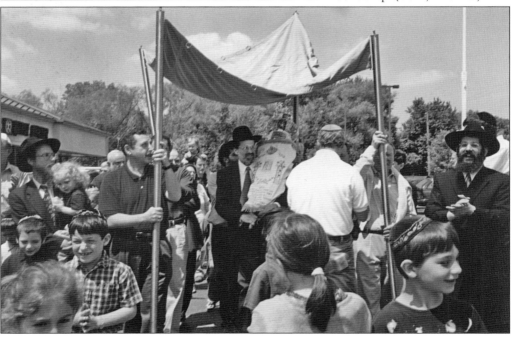

Temple Israel dedicated its new, more centrally located home—just north of Downtown Dayton across Patterson Boulevard Bridge—on November 13, 1994. Senior Rabbi P. Irving Bloom (left) and Asst. Rabbi Mark Glickman led the service. A year later, the community held its memorial service there a day after Israeli prime minister Yitzhak Rabin's assassination; diplomats negotiating the Dayton Peace Accords attended, including Gen. Wesley Clark. (Temple Israel.)

When Temple Israel needed a Torah ark for the High Holy Days in its new social hall, it turned to "The God Squad," volunteer woodworkers who have crafted pieces for use in houses of worship across several denominations in the region. Shown here, working on an ark for Chabad, are (from left) William Wright, Dr. Michael Jaffe, and Dr. Burt Saidel. Not pictured are A.B. Goldberg and Harold Prigozen. (DJO.)

Cantor Joyce Ury Dumtschin was an active volunteer with the Dayton Jewish Committee on Scouting. Here, she joins Girl Scouts (including her daughter, Rachel, at her right) at Beth Abraham Synagogue for the committee's annual Scout Shabbat. Dumtschin began leading Temple Beth Or's choir in 1987. She was invested as a cantor in 1998 and set arrangements for more than 100 vocal and piano works of liturgical music. (DJO.)

In 1975, Jews who had moved to the area and lived south of Dayton established the Jewish Association of South Dayton to connect their families through social, cultural, and educational events. By the 1980s, with more than 300 members, the association ran preschool and middle school programs and led monthly Shabbat services at Temple Israel's south facility. Here, members gather in the early 1990s. (Dena Briskin.)

Dayton Jewish Community Center Early Childhood Services director Lynda A. Cohen explains the significance of Simchat Torah to children. Parents entrusted their little ones to Cohen for more than 30 years beginning in 1970, when she was the center's camp director and its lead early childhood teacher. She served as early childhood director from 1981 until her retirement. In her later years, the children often called her "Bubbie" (grandmother). (DJO.)

Rabbi Hillel and Chana Fox present a consecration class at Beth Jacob Synagogue. In 1994, Hillel Fox became the Traditional congregation's rabbi, with the approaching retirement of his father, Rabbi Samuel Fox, as he neared 40 years with the synagogue. Chana Fox taught in the lower grades at Hillel Academy Jewish day school and led the Dayton Ritualarium Society, which operated Dayton's mikveh. (Beth Jacob Synagogue.)

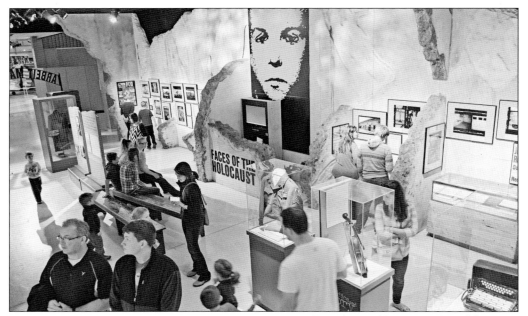

Prejudice and Memory: A Mobile Holocaust Exhibit, curated by Dayton Holocaust Committee chair Renate Frydman (at left in the image at left), made its debut in 1997 at the Dayton Museum of Natural History. The exhibit was one of the first in America to focus on local survivors, liberators, and Righteous Gentiles. In 1999, it became a permanent exhibit at the US Air Force Museum (above), and is seen by approximately 1 million visitors annually. The exhibit includes a Buchenwald concentration camp uniform from the Bomstein family, and the violin of Robert Kahn, who was forced to play it while Nazis beat his father on Kristallnacht. Frydman is shown with US Air Force Museum director Maj. Gen. (Ret.) Charles Metcalf. Frydman also produced the *Faces of the Holocaust* series of video interviews with Wright State University. (Above, National Museum of the US Air Force; left, DJO.)

Violinist Itzhak Perlman (left) joins philanthropists Leonore and Larry Zusman to inaugurate new facilities in the tunnels under the Western Wall in Jerusalem in 1994. The couple funded an extensive project to make the tunnels accessible for people with disabilities. The Zusmans founded Price Stores in Dayton in 1950. Larry Zusman was also a real estate developer. In Israel, they supported numerous other projects for those with disabilities. In Dayton, the Zusmans provided for the addition of a wing to the Jesse Philips Building in 1988 to house Jewish Family Service, and in 1999 they endowed the Zusman Chair of Judaic Studies at Wright State University, held by Dr. Mark Verman; below. (Above, American Jewish Joint Distribution Committee; below, DJO.)

Carole Rabinowitz visits an Ethiopian absorption village in Israel's Western Galilee in 1991, months after Israel's military launched Operation Solomon, which airlifted 14,325 Ethiopian Jews from politically unstable Ethiopia to Israel over 36 hours. The Jewish Agency, a beneficiary of Jewish Federations, provided key funding and absorption services. In 1996, Dayton would join the Jewish Agency's Partnership 2000, building relationships with Israelis in the Western Galilee. (Bernie Rabinowitz.)

Hyla Weiskind (left), senior adult services coordinator for the Jewish Community Center and Jewish Family Service, visits Esther Gurevitz —daughter of Rabbi Samuel and Lillian Burick—at Covenant House. Weiskind empowered seniors, organizing daily activities for the Jesse Philips Building's senior lunch site. With Jewish Family Service, she also started the Bikur Haverim Friendly Visiting Program to connect volunteers with Jewish seniors. (JFGD/WSU.)

In 1998, fifty years after the establishment of the Jewish state, Dayton's synagogues and Jewish Federation brought 74 people to Israel on a family mission. The highlight was a bar and bat mitzvah ceremony for 16 Dayton youths at the Southern Wall of the Temple Mount in Jerusalem. Six mothers and grandmothers who never had their own bat mitzvah ceremonies also participated. (Bruce Feldman.)

Deborah Feldman began her work with Montgomery County in 1981 and was named county administrator in 1997. Along with Dr. Stuart Weprin, Feldman chaired the Dayton Jewish Education Commission, which in 1997 created B'Yachad, the supplementary high school for Jewish studies. She went on to serve as president of the Jewish Federation, and years later would become president and chief executive officer of Dayton Children's Hospital. (DJO.)

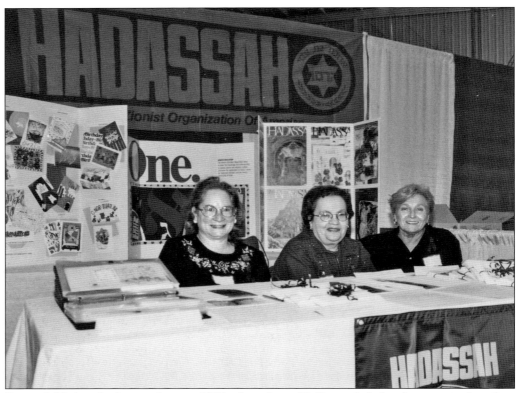

Dayton's Hadassah chapter dates to 1925, when Anna K. Osness led the charge as its founding president. She even received written congratulations from Henrietta Szold, the founder of Hadassah. With its mission to advance women's health, Zionism, and to support Hadassah Medical Organization in Jerusalem, Dayton's Hadassah hosted fashion show fundraisers for decades. Shown here are Hadassah members (from left) Sandy Schoemann, Ellin Oppenheimer, and Leonore Sonnenschein. (DJO.)

Dr. Kim Goldenberg, dean of Wright State University's medical school, was named the university's president in 1998 after the death of university president Harley E. Flack. During Goldenberg's tenure, student enrollment expanded, as did research awards. Before he became a physician, the native New Yorker was an engineer, managing aeronautical and bioengineering projects for Grumman, NASA, and the Navy. He tested critical parts for the Apollo lunar lander. (DJO.)

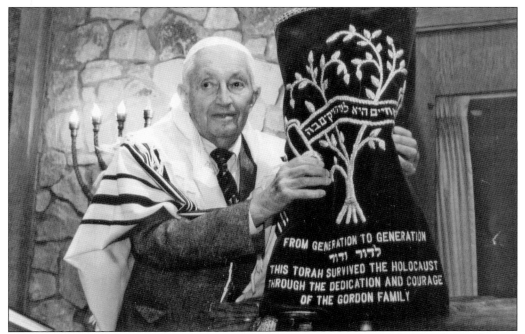

When the Gordon family arrived in Dayton in 1951, they carried a Torah from their village in Poland. Elia Gordon begged a non-Jewish farmer in 1941 to hide his synagogue's Torah before the Nazis arrived. The Gordons survived the Holocaust, and the farmer returned the Torah. Here, Elia Gordon's youngest son, partisan fighter Maurice Gordon, displays the Torah, which the family donated to Beth Jacob Synagogue. (Beth Jacob Synagogue.)

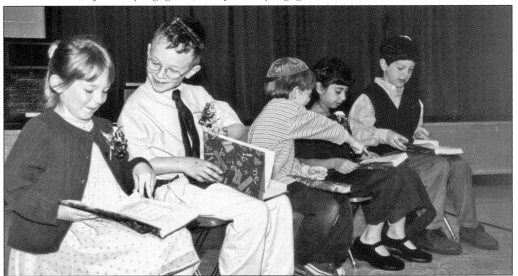

A longtime rite of passage at Hillel Academy has been the siddur (prayer book) presentation to each first grader after an intensive year of learning the prayers in Hebrew and their meanings. Exploring their siddurs at the ceremony are (from left) Marla Guggenheimer, Micah Rhodes, Andrew Cohen, Neta Sitton, and Jack Fuchsman. During the program, the first-grade class leads the morning service in the presence of their parents. (DJO.)

Discover Thousands of Local History Books
Featuring Millions of Vintage Images

Arcadia Publishing, the leading local history publisher in the United States, is committed to making history accessible and meaningful through publishing books that celebrate and preserve the heritage of America's people and places.

Find more books like this at
www.arcadiapublishing.com

Search for your hometown history, your old stomping grounds, and even your favorite sports team.